IN PRAISE OF THE NEEDLEWOMAN

EMBROIDERERS, KNITTERS, LACEMAKERS,
AND WEAVERS IN ART

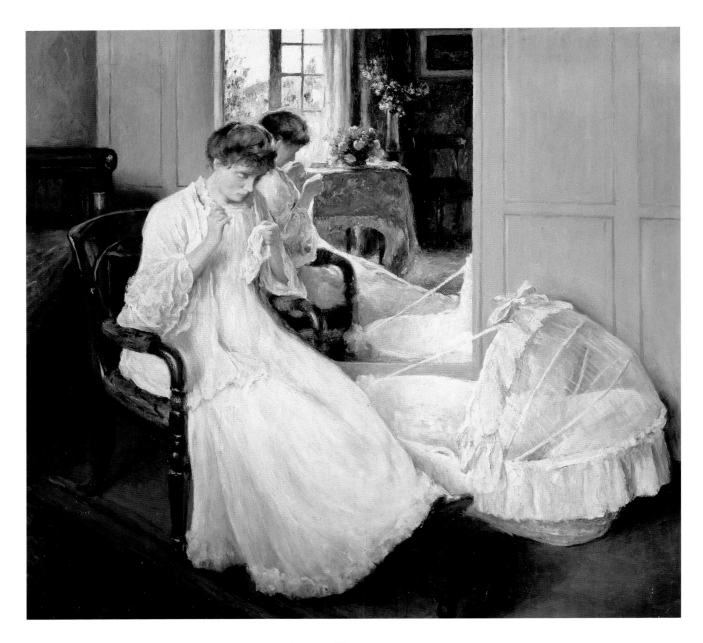

André Collin, 1862–1930

Motherhood, 1916

MUSÉE DES BEAUX-ARTS, TOURNAI, BELGIUM

GAIL CAROLYN SIRNA

FOREWORD BY SHAY PENDRAY

IN PRAISE OF THE NEEDLEWOMAN

EMBROIDERERS, KNITTERS, LACEMAKERS, AND WEAVERS IN ART

MERRELL
LONDON · NEW YORK

First published 2006 by Merrell Publishers Limited

HEAD OFFICE
81 Southwark Street
London SE1 0HX

NEW YORK OFFICE
49 West 24th Street, 8th floor
New York, NY 10010

merrellpublishers.com

PUBLISHER Hugh Merrell
EDITORIAL DIRECTOR Julian Honer
US DIRECTOR Joan Brookbank
SALES AND MARKETING MANAGER Kim Cope
ASSOCIATE MANAGER, US SALES AND MARKETING
 Elizabeth Choi
MANAGING EDITOR Anthea Snow
PROJECT EDITORS Claire Chandler, Rosanna Fairhead
EDITOR Helen Miles
ART DIRECTOR Nicola Bailey
DESIGNER Paul Shinn
PRODUCTION MANAGER Michelle Draycott
PRODUCTION CONTROLLER Sadie Butler

British Library Cataloging-in-Publication Data:
Sirna, Gail Carolyn
In praise of the needlewoman : embroiderers, knitters,
lacemakers, and weavers in art
1.Needlework in art 2.Women in art 3.Painting,
European 4.Painting, American
I.Title
758.9'7464

ISBN 1 85894 341 8

Designed by Karen Wilks
Edited by Mary Scott
Indexed by Hilary Bird

Printed and bound in China

FRONT COVER
John William Waterhouse
"I am Half Sick of Shadows," said the Lady of Shalott
p. 171

BACK COVER, LEFT TO RIGHT
Joseph Court
*Rigolette Seeking to Distract Herself during the
Absence of Germain*
p. 47

Marcus Stone
In Love
p. 113

Salvador Dalí
Woman at a Window in Figueras
p. 177

PAGES 12–13
Frederick C. Frieseke
Tea Time in a Giverny Garden
p. 160

CONTENTS

FOREWORD
Shay Pendray

Needlework has been with us since the earliest civilizations. At first, people covered themselves with leaves or skins, which needed to be attached to each other. Holes were made and sinew or vines were threaded through the holes. It was an easy next step to start embellishing the coverings with bits of shells, rocks, and colored vines, threaded crudely in simple stitches. Hence embroidery was born.

With the creation of a simple hole in a thorn or fish-bone, the needle was born. This was one of the greatest ever inventions. The fish-bone or thorn needles later evolved to bronze, then steel. Metal needles were used in China as early as 3000 BC. The art of making needles spread worldwide, and in many cultures a needle was a woman's most prized possession. She worked days, months, or even years in order to acquire a steel needle. Once it was obtained, she kept it in a special place. It was the tool she used to make clothing, household items, and even, in the cases of the Mongolian yurt, her house. The nomadic women of Mongolia used elaborately decorated metal needlecases, filled with a cushion of horsehair, which they hung from sashes, and they considered the needle more important than gold. Once lost, a needle could take a lifetime to replace.

Women are the keepers of embroidery stitches and patterns that have been handed down from one generation to another from the earliest times, and they have strived to continue this practice down the ages. Embroidery patterns are used to establish historical timelines and even define cultures.

Embroidery sets one culture apart from another. In Japan, the obi and kimono, elaborately embroidered, can reveal the age, wealth, and social and marital status of the owner. In China, embroidery could even depict the life story of the wearer. The cultivation of the silk worm enabled the Chinese also to practice the art of silk embroidery. Silk was carried along the Silk Road and was traded in place of gold, such was its importance. In Africa, bright colors in repeat geometric patterns are worn by women and men alike to identify where the wearer comes from, the time of year and, in some cultures, the age of the wearer. Certain patterns and colors are reserved for the unmarried, the married, or the head of the clan. Archaeologists use embroidery patterns and textiles to date certain pieces because the same patterns are used to decorate pottery and architecture.

Embroidery is present in many religions, used to decorate the priest's vestments, altars, and wall hangings. American Indians have heavily beaded robes and bags for their ceremonies.

The way in which embroidery patterns were recorded was to take a piece of cloth and stitch the patterns as a reference. This reference was then traded with other people, who would copy the patterns, handed down from one generation to another, and became known as a sampler, or a record of the patterns and stitches. These pieces of cloth were a 'recipe book' of stitches that were never intended to be finished, signed, or hung, but were just a practical way of remembering. When you ran out of space you simply took another piece of cloth. Over the years they became more formal, were used as a tool to teach young women their letters, and today are prized collectors' items. The recording of these patterns in published books has led to these books becoming the means by which embroidery styles and techniques are passed on to future generations.

The pictures that Gail has so lovingly collected and cataloged in this book will serve to pass the depiction and enjoyment of needlearts on through the generations, and they illustrate just how important a tool embroidery is in all our lives. With this book, Gail thus continues this historical tradition of women sharing and passing on embroidery down the generations.

Needlework defines our history, establishes our traditions, and will be an important part of our future. Women will continue to hand the traditions of the embroideries of their culture to future generations, as they have done through the ages.

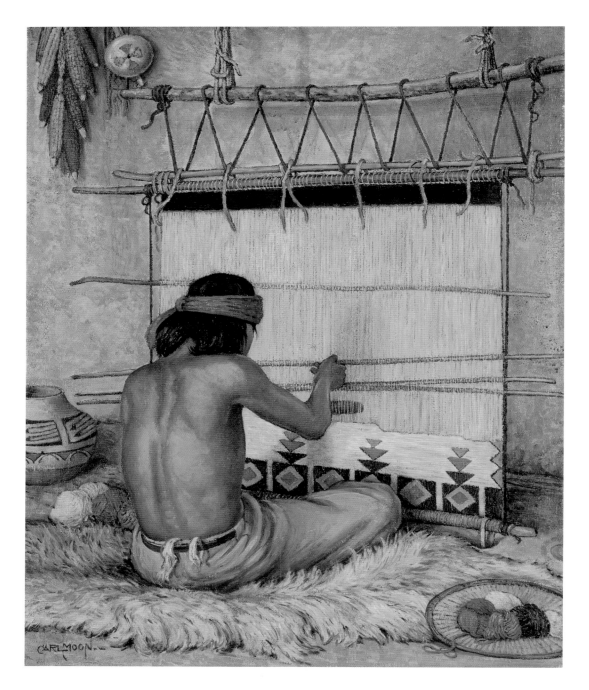

Carl Moon, 1878–1948
Hopi Weaver, c. 1937–43
NATIONAL MUSEUM OF AMERICAN ART, WASHINGTON, D.C.

INTRODUCTION

Of all the activities associated with women, needlework is one of the most universal, second only, perhaps, to childbirth and childrearing. Women of all times, all places, and all stations in life have taken needle in hand, either for the most utilitarian of purposes, such as mending or garment construction, or for the most artistic reasons, such as silk embroidery or tapestry work. For peasant and princess, cave dweller, and career woman, needlework has been a most gratifying endeavor for the human being, especially woman. Indeed, one of the earliest tools associated with humans is the needle; it has survived for eons in its same form, the only change the materials from which it is made.

Some women sew by necessity; others with passion. We of the twenty-first century are fortunate that only those who love needlework need do it. For us it is an artistic expression or perhaps a relaxing pastime.

It is hardly surprising that many artists over the centuries chose the needlewoman as their subject. We find both portraits and genre paintings featuring needleworkers. In the seventeenth century, Dutch artists painted many genre scenes showing a peasant woman dutifully plying the needle. In some (alas very few) commissioned portraits of the eighteenth century, on both sides of the Atlantic, the noblewoman is shown with her embroidery. And from the late nineteenth century, when the Impressionist movement was at its height, there exist a myriad of beautiful paintings of the needlewoman.

It must be remembered that in most instances the artist painted what he could sell, so that the dearth of "stitcher" paintings in the seventeenth and eighteenth centuries indicates that this was not a popular theme with clients. Similarly, the popularity of paintings of the needlewoman in the nineteenth century demonstrates the prestige of the activity at the time and the aura surrounding the woman so engaged.

The nineteenth-century young woman was expected to be "accomplished"; that is, she could read well enough to write a letter, could sing a few pleasing songs, but more importantly, she was expected to be a proficient needlewoman. The painting of a young woman stitching became a metaphor for the educated but submissive young woman, one who would be a good wife. Parents hung the framed needlework of their marriageable daughters in prominent places around the family home, and the embroidery frames were displayed in public areas of the household for all to see, especially eligible young men or their parents.

When visitors came, the compliant daughter would be busy at her embroidery.

Today I often hear non-stitchers bemoan the fact that the needlework skills of the past have been lost. They will produce a treasured item made by a grandmother or great-grandmother, and will declare sadly that no one does work like this any more. Even museum curators can fall into this misapprehension. However, this is not the case. There are numerous guilds throughout North America and the United Kingdom with enthusiastic members who pursue the needlearts passionately. Indeed, in the United States and Canada, both nations of immigrants, the guild members eagerly embrace any ethnic embroidery to which they are introduced. They add the techniques or designs to their already wide-ranging repertoire of needlework skills, and eventually combine elements from various traditions to create a new, uniquely American style. This intermingling of embroidery styles to create something new is the very essence of American-ness: the proverbial melting-pot of nationalities.

For years I have belonged to, and taught for, the Embroiderers' Guild of America, the American Needlepoint Guild, and the Embroiderers' Association of Canada. These groups have chapters nationwide, and each year they offer national seminars, with classes and exhibits, for interested members. These are widely attended. As a teacher I design pieces that I then help my students interpret; they make copies of my design, or perhaps use it as a jumping-off point for their own creative endeavors.

Often these local chapters request a presentation for their entire group, comprising possibly sixty to a hundred people, and it is from this that my search for "stitchers" evolved. Several years ago I decided to collect images of needleworks that portrayed the human form for my presentation "Portraits in Embroidery." For it I acquired images both from my colleagues and from other stitchers that showed different types of stitched portraits. To introduce the presentation I thought it might be interesting to show how painters had also depicted the human figure; in fact, such portraits were a common form of painting, and often the means by which an artist supported himself. Since this presentation was directed at stitchers, I thought it would be appropriate to include several paintings that depicted women stitching.

This task turned out to be much easier than I had anticipated. Right away I was able to identify numerous paintings that showed women engaged in sewing, embroidery, or some other related needleart. I discovered these in address books and day journals, on calendars, postcards, and posters; most of them were commonly available in bookstores or museum shops. The Impressionists were prominently represented, undoubtedly because their art is very popular in America today, and sells well.

In the process I became entranced with the paintings. I could not refrain from searching for them, and everywhere I looked I found more. I eagerly bought up the calendars and day journals, and the postcards, then graduated to art books

and the occasional poster. I had soon identified enough paintings of people stitching, knitting, crocheting, weaving, spinning, or making lace, to produce a second presentation, "In Praise of the Needlewoman." This title is an allusion to an early needlework poem called "In Prayse of the Needle."

So engaged did I become in this search that I decided to enter the Honors Program at the National Academy of Needlearts. In this program one researches a topic related to the needlearts, writes a thesis-length paper, makes a presentation for the membership at the annual seminar, and stitches a piece to reflect the research. The embroidered piece is then donated to the Academy's permanent collection, which is housed at the Gallery of Art and Design at North Carolina State University in Raleigh.

This book has evolved from my Honors research. I discovered many artworks that depict the stitcher, about 480 at the time of writing, and from all over the world. My slide presentation is directed at the many needlework and knitting guilds across the nation, and this book, comprising a selection of the images, is a small part of that. My research started out as a casual interest; the more I looked the more it became a passion and, ultimately, something of an obsession. In pursuit of this passion I have visited more than fifty museums across North America, Europe, and China. I have spent countless hours on museum websites in the hope of discovering more art devoted to my favorite subject, the needlewoman.

During the course of this project I have come to realize that sewing and embroidery are the "threads" that bind us (mostly women) to past generations and future generations, and to women around the world. The paintings I have identified date back as far as the 1400s, showing that women were doing handwork then, just as now. The artists who painted these women are from all over the Western world, and indeed the Eastern world, too. Every culture has sewing and embroidering in some fashion, as has every era. Literature gives us even more proof of this—sewing and weaving are mentioned as early as the Old Testament. Even today, women—and some men—all over the world are busy with their handwork. Some do it professionally, some from necessity, some do it for pleasure, some for creative expression. But it is my observation that in all cultures, and in all times, there is an imperative to take needle and thread in hand and produce something either useful or decorative. And often, once dire necessity is overcome, this stitching becomes decorative and ultimately artistic.

Along the way I have developed some other fascinations. One is with women artists, so often forgotten or never recognized. Often stitchers were painted by women artists, who were limited in the contact they had with men and so devoted themselves to painting other women.

And so the paintings of needleworkers will remain a lifelong quest; I will never stop looking for them, and will probably continue to collect images long after the occasion for giving my presentation has ceased to exist.

I have even found time to stitch some needlewomen myself.

IN PRAISE OF THE NEEDLEWOMAN

Gabrielle d'Estrées and One of her Sisters

There is much speculation about the meaning of this enigmatic painting. The woman on the right is Gabrielle d'Estrées, the royal favorite and second mistress of Henri IV, King of France. She lived in the late sixteenth century and died in childbirth at the age of twenty-six. The title of the painting indicates that her companion in the bath is her sister, Juliette, but others theorize that the woman doing the pinching is Henriette d'Entrangues, who succeeded Gabrielle as Henri's mistress.

Some interpret the pinch as a symbol of Gabrielle's pregnancy: it was she who gave the king two male heirs, and for this reason she was almost elevated to queen. However, other historians hypothesize that this pinch is a symbol of Henriette's supplanting Gabrielle as the king's favorite, only a short time after her untimely death.

If one can look beyond this startling scene in the foreground of the painting, there is someone stitching in the room behind the two leading ladies. This woman is probably a maidservant to Gabrielle, and she appears to be making lace, although one cannot be absolutely sure. Lace was at the height of its popularity in the late sixteenth century, and was very expensive. This stitcher could reflect the riches that have been showered upon the fair Gabrielle, but which she would possess for only a brief time .

Alternatively, this figure may only be a painterly device to put a spot of red in the center of the painting to balance the red draperies that frame the two protagonists. Whatever the case, this small woman bent over her neeedlework enlivens the space between the two beauties in the foreground.

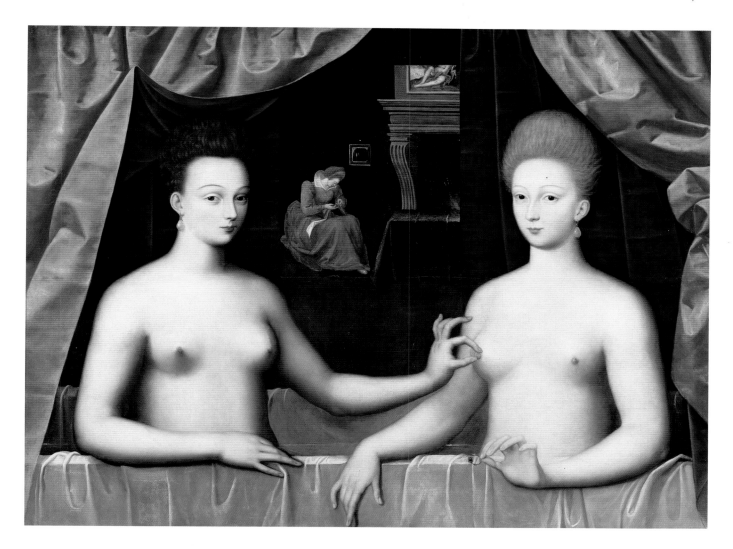

Master of the Fontainebleau School
(active second half of the sixteenth century)
Gabrielle d'Estrées and One of her Sisters, c. 1595
LOUVRE, PARIS

The Proposition

In *The Proposition*, also known as *The Rejected Offer* or *Man Offering Money to a Young Woman*, a rather sly-looking fellow offers some coins to a young woman, who remains earnestly intent on her needlework. Is he suggesting some nefarious activity, or is he merely indicating that he will be able to offer her a comfortable life, were she to agree to marry him?

The woman, meanwhile, ignores him, although of course she is aware of his presence; his hand is on her arm. From her attire we may infer that she is a maidservant; her dress is modest, and her hair confined in a bun, with a servant's cap on her head. She does not appear to be a prostitute, but a woman of virtue, for she is simply garbed and plainly coiffed. She concentrates on her embroidery, her eyes resolutely on the needlework, and her posture indicates that she wants nothing to do with him.

In seventeenth-century Holland, the art of needlework was considered a valuable education for women, and is often included in both paintings and literature as symbolic of virtue and diligence.[1] It was not a device to make a woman more alluring to a potential husband, as was true in the nineteenth century, but more as a safeguard against idleness, and subsequent descent into debauchery. To the rather puritanical Dutch, sloth was the most evil of vices.

Judith Leyster was, until recently, not even a recognized artist. This is all too often the fate of early women painters. She was a student of the Dutch painter Frans Hals, and indeed some of her work was attributed to him. Her marriage and subsequent motherhood somewhat impeded her career; however, it is felt that her sensitive portrayals of the working class were an influence on such later artists as Jan Vermeer.[2]

This painting is known by at least three different titles, as indicated above, which suggests that the scenario presented is at best ambiguous. It is also difficult for us to understand symbols and messages from such a remote period in history, even one so well researched.

1 *Judith Leyster: A Dutch Master and Her World*, exhib. cat., ed. Pieter Biesboer and James E. Welu, Frans Hals Museum, Haarlem, May–August 1993; Worcester Art Museum, Worcester MA, September–December 1993, pp. 168–71.
2 Margaret Barlow, *Women Artists*, Westport CT (Hugh Lauter Levin Associates) 1999, pp. 30–31.

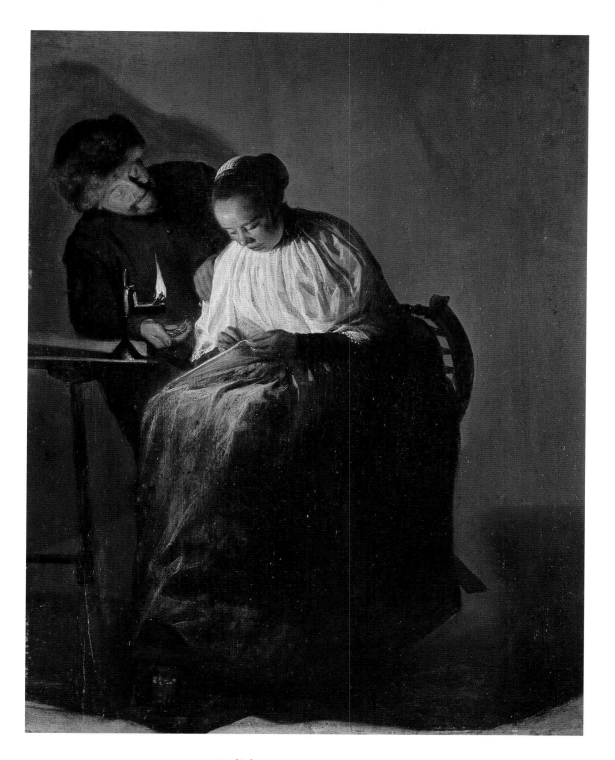

Judith Leyster, 1609–1660

The Proposition, 1631

MAURITSHUIS, THE HAGUE, THE NETHERLANDS

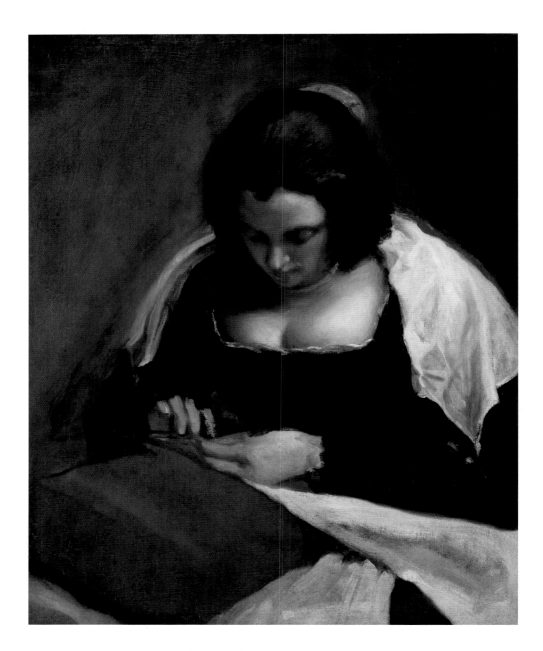

Diego Velázquez, 1599–1660
The Needlewoman, c. 1640–50
NATIONAL GALLERY OF ART, WASHINGTON, D.C.

The Needlewoman

The renowned Spanish painter Diego Velázquez is particularly revered for his masterful work *Las Meninas* (The Maids of Honour, *c.* 1676, Prado, Madrid), which pictures the royal family of Spain in the mid-seventeenth century. *Las Meninas* is complex and exquisitely detailed, and reveals numerous levels of interest. Velázquez made his living as court painter to Philip IV of Spain, but would occasionally paint more mundane subjects if they interested him. *The Needlewoman* is one such painting, and is much simpler than *Las Meninas*. It is possible that the model is the painter's daughter.

She sits with her head tipped forward, and her hands are at bosom level as she works on a length of white cloth. Like the work of many other "stitchers" painted in the seventeenth century, and especially those painted in Spain, the sewing is propped on a large pillow, which has not been painted in. Perhaps this was a device to keep the sewing at the correct working height, for several other seventeenth-century paintings show a similar arrangement, for example: Francisco de Zurbarán, *The Girlhood of the Virgin* (see pp. 22–23) and *The Young Virgin, c.* 1632–33 (The Metropolitan Museum of Art, New York); Bartholomé Esteban Murillo, *The Holy Family with the Infant St. John* (see pp. 24–25); Guido Reni, *The Girlhood of Virgin Mary* (1610s, State Hermitage Museum, St. Petersburg).

The needlewoman is plainly garbed in a dark gray dress, with only a little lace at the low square neckline, and possibly some at the cuffs. This was a time when, in Spain at least, women of moral virtue did not reveal their bosoms or even their arms; nevertheless, the needlewoman seems not to be a person of loose morals, but merely someone intent on her work. Velázquez has allowed light to play upon the bosom of the stitcher, and it is this element one sees first. Across her shoulders is draped another white cloth, probably her partlet, which would tuck into her neckline.

The needlewoman's hair is surprisingly modern in appearance, with its medium-length soft curls. Even the swept-back hair at the forehead, revealing a prominent widow's peak, has a contemporary feel to it. There is a red ornament on the back of her head, which does not seem to be actually confining any of her hair; the function of this element is unclear, but its color attracts the attention of the viewer.

With the exception of the woman's face, this painting has not been completed, hence the uncertainty as to whether there is lace at the cuffs. It reveals to the observer the techniques that Velázquez employed to achieve the effects he desired, especially the luminescence of the complexion.

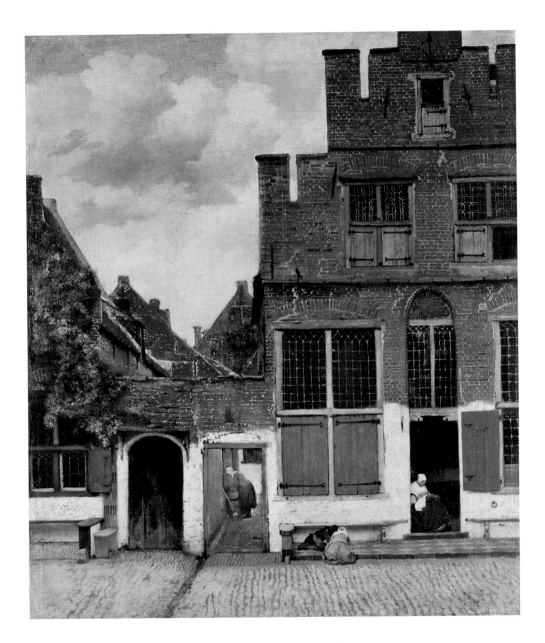

Jan Vermeer, 1632–1675
Little Street, 1657–58
RIJKSMUSEUM, AMSTERDAM

Little Street

Such paintings as *Little Street* afford twenty-first-century people a glimpse into the everyday world of seventeenth-century Holland. Jan Vermeer has depicted an ordinary street in his home town of Delft, and the composition gives us insight into the architecture of the time, as well as the lives of the townspeople. The houses are huddled close together, and sit right on the edge of the street. There are no grassy areas, or even pots of flowers, to break up the sense of solid stone and brick. The chimneys reflects what an integral feature they were of homes at the time, when heat was supplied by fireplaces and wood-burning stoves. Interesting also are the leaded windows: the upper sections are large and unshuttered to admit light, in a climate in which the sky is often overcast. Below, colorful shutters block the glance of curious passers-by. The street itself is well-worn cobblestone, and the narrow sidewalk appears to be of patterned tile.

One curious feature is the benches in front of the houses. Are these for visiting with neighbors, or are they a place for children to play? A doorway opens into a courtyard and we see hints of a separate building in the rear. Were these secluded spaces just for household chores, or an area for private family recreation?

Four people are depicted in this painting. Immediately one notices the woman in the doorway, busy at her needlework, but perhaps also keeping an eye on the children playing on the sidewalk nearby. It's easy to overlook these children; the girl's dress blends so well into the cobblestones. In the open doorway to the left another woman is visible; most likely she is a maidservant taking care of the laundry.

The bold contrast between the dark-red brick of the buildings and the cloudy sky first attracts the eye, but this painting is less about architecture than it is about the lives of the virtuous women of the day. After acknowledging the roof line of the house, one's eye is immediately drawn to the woman and her needlework; her white clothing contrasts sharply with the dark interior. Needlework was a skill much valued by the Dutch at this time, and women of all stations were expected to be accomplished.

Our eyes are also drawn to the maidservant busy with her laundry; housework and cleanliness were highly regarded in Holland in the seventeenth century. Our attention is directed to her by the small drainage sluice that carries water away from her. The sparkling water leads the eye directly to her and her mundane task.

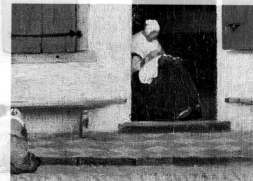

Most of Vermeer's paintings are of interiors, with one or two people engaged in some daily activity. *Little Street* is unusual for this artist, in employing a street scene as the setting.

The Girlhood of the Virgin

The Spanish painter Francisco de Zurburán has painted the Virgin Mary as a little girl—surely not older than eight or nine—and has captured her in a contemplative moment, at once unusual and moving. Mary appears solemn, melancholy, and ethereal. She has put down her sewing and placed the needle in the cushion; her hands are folded in prayer, her eyes gaze heavenward. She wears not the blue normally associated with the Virgin, but a light-red gown edged with gold embroidery. Possibly the red is a symbol of the blood that will be shed by her son.

Mythology tells us that, as a child, Mary's labor in the Temple was to work on the Great Curtain, which was rent at the moment of Christ's death. Perhaps this cloth foreshadows that awful event. Perhaps, too, it evokes the shroud of the Piéta, with which her son would be wrapped.

There is little else in this painting to tell us about the artist's feelings about this subject; only the heavenly light shining on Mary's innocent face, showing her sorrow and humanity.

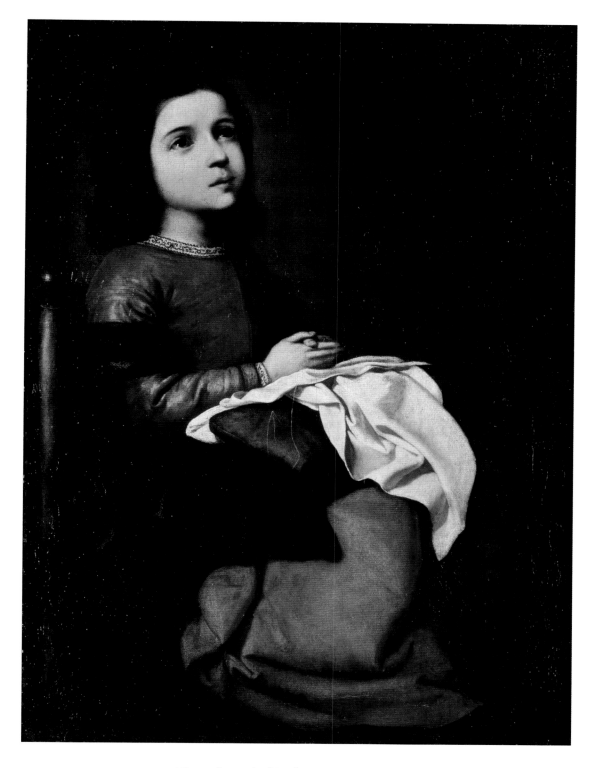

Francisco de Zurburán, 1598–1664
The Girlhood of the Virgin, c. 1660
STATE HERMITAGE MUSEUM, ST. PETERSBURG, RUSSIA

The Holy Family with the Infant St. John

Religious paintings were produced in large numbers in seventeenth-century Europe, and Spain was at the epicenter of religious fervor. Painters tended to concentrate on subjects from the Bible or the lives of the saints, which were worked both for church interiors and for the homes of the wealthy. Bartholomé Murillo was among the noted artists of his day, along with Velázquez and Zurburán. Murillo is most remembered for his sensitive portrayals of the Virgin Mary and his often sentimental paintings of the people of Seville.

In his *Holy Family with the Infant St. John*, Murillo draws attention to the Virgin Mother, depicting her as a very young woman who keeps a careful eye on the toddler Jesus. Jesus plays with his cousin John, later to be known as St. John the Baptist. Ethereal light falls upon the face of Mary and on the tiny Jesus, suggesting that they are in the state of grace. John is more in the shadows, as is Joseph, who works in the background. The children appear to be playing with some discarded sticks from the carpentry work going on behind them, and they have fashioned a cross, undoubtedly intended to be a symbol of the future of Jesus, and an icon of the church founded by Him.

Mary, meanwhile, is busy with her sewing, her hand poised mid-stitch as she notices how the children are occupying themselves. Her sewing rests on a pillow on her lap, a similar device to that in Velázquez's *The Needlewoman* (pp. 18–19). Mary is working on a long length of cloth, which could prefigure Christ's shroud, as in Zurburán's *The Girlhood of the Virgin* (pp. 22–23). In that time looms were narrow, and large items like sheeting and curtains had to be hand-pieced to produce the desired width. A basket with more sewing sits at Mary's feet. Joseph is shown in the background industriously engaged in his carpentry work. Murillo includes parts of the house and workshop, managing simultaneously to have Joseph out of doors with Mary inside near the hearth.

This painting would have been well received in seventeenth-century Spain, with its romanticized religious theme and domestic subject. Murillo has included all the important elements in what could be considered a morality painting: idealized family life, the virtue of hard work, the sanctity of motherhood, the innocence of childhood.

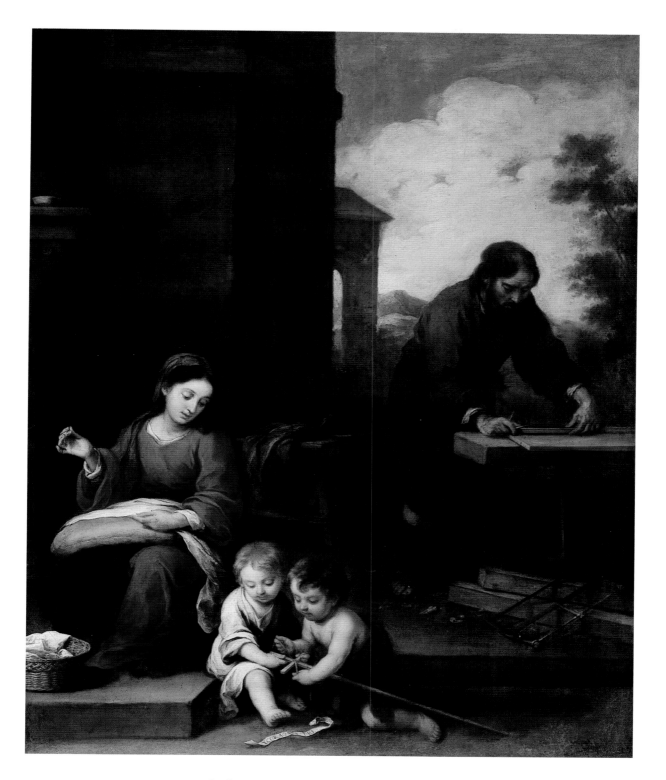

Bartholomé Esteban Murillo, 1617/18–1682

The Holy Family with the Infant St. John, c. 1665

MUSEUM OF FINE ARTS, BUDAPEST

The Lacemaker

The Lacemaker is a widely recognized and well-loved painting by Jan Vermeer, the seventeenth-century Dutch painter. Unlike most Vermeer paintings, *The Lacemaker* has no background detail and therefore no actual setting. There is no story being told: we focus only on the lacemaker herself. This is a surprisingly small painting, only about 9 × 8 in. (23 × 20.5 cm), but its image is known worldwide. Vermeer has created a small triad of primary colors; the pure yellow of the lacemaker's gown is balanced by the blue of the working pillow and the red threads that cascade on the left.

The pure lemon yellow of the subject's dress first attracts the eye; the gown is bathed in brilliant light and is the most noticeable feature of the painting. Next we take note of the flawless complexion of the woman's forehead and the intensity of her fingers, as she holds several bobbins and adjusts a pin. Because there is little else in the painting, the viewer concentrates on the subject herself; the intensity of her posture and her fingers is communicated strongly to us. She appears to be a disciplined technician, fully concentrating on her work, permitting nothing to distract her from this exacting art. Even her hairstyle seems disciplined by today's standards, the tightly confined bangs and the carefully constructed braid suggesting a controlled life; only the escaping curl on her left possibly alludes to her creative nature.

The lacemaker wears a wide lace collar. Since lace was very dear in this era, and usually only affordable to the most affluent, we might surmise that this woman is not a lacemaker by trade, but perhaps engages in the art for the love of it. The collar is no mere token of this exquisite form; it is lavish and opulent and bespeaks a comfortable level of existence.

During the seventeenth century, a time when painters in other countries concentrated on royalty, nobility, and religious figures for their subjects, the Dutch painters began to produce genre paintings. They depicted ordinary people engaged in everyday activities, and these were often morality paintings, extolling the virtues of hard work. In this painting, Vermeer has composed a paean to human creativity and diligence, in which these virtues are paralleled with those of religious devotion. One of the few objects in *The Lacemaker* is a book, shown on the table to her right. Although there is no lettering to be seen, we may assume that this is either a prayer book or a Bible, testifying to the sitter's spiritual virtue.

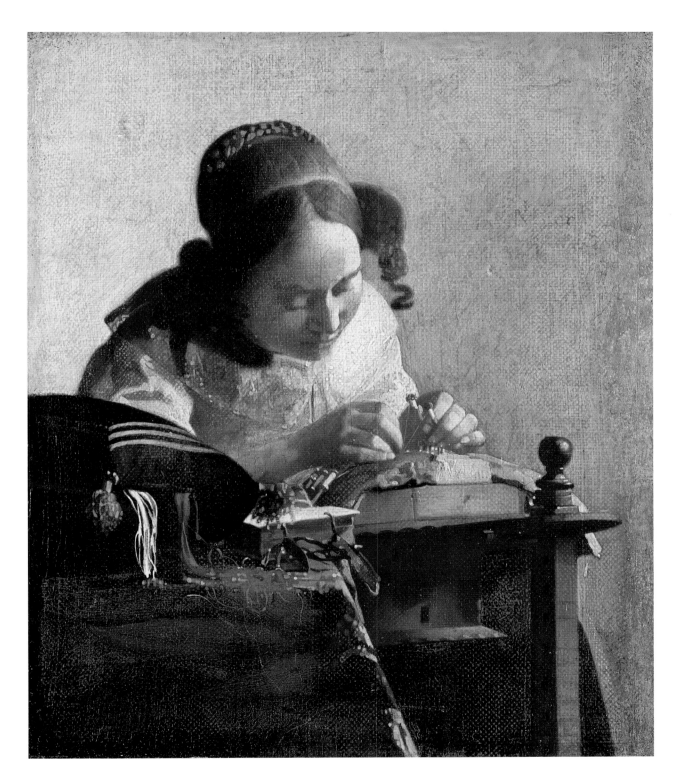

Jan Vermeer, 1632–1675

The Lacemaker, c. 1669–70

LOUVRE, PARIS

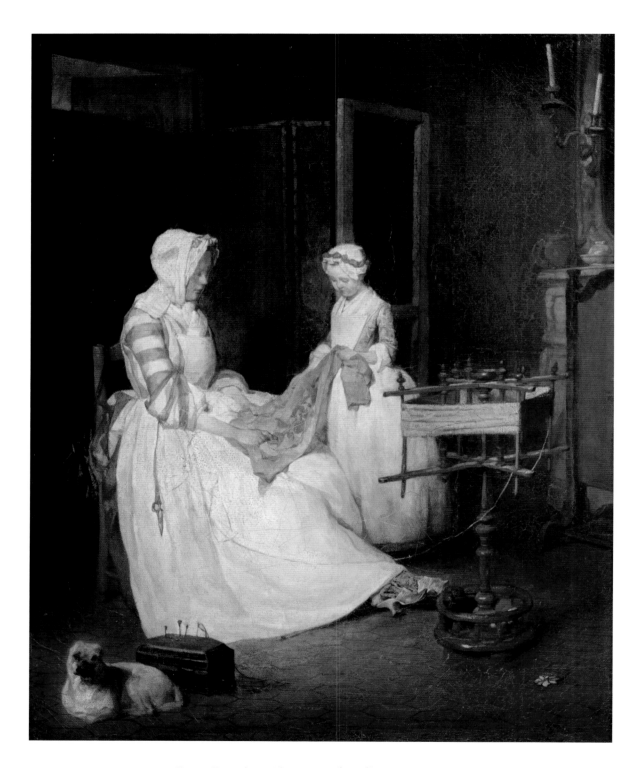

Jean-Baptiste Siméon Chardin, 1699–1779
The Industrious Mother, 1740
(*La Mère laborieuse*)
LOUVRE, PARIS

The Industrious Mother
(La Mère laborieuse)

The French artist Jean-Baptiste Siméon Chardin has created a quiet domestic scene, which is characteristic of his genre work. In *The Industrious Mother*, he depicts a mother and her young daughter in their middle-class home. Both wear long, voluminous aprons that cover their skirts, so it is difficult to discern the quality of the woman's dress. However, their status is betrayed by the shoes the mother wears: they are colorful high heels. Both mother and daughter have their hair almost totally covered, in what was the style of the day, and one worn by many sitters in Chardin's large body of genre paintings.

The mother sits in front of a folding screen, near a fireplace that seems to offer some warmth and light. Two candles appear to sway precariously in their sconces, but seem to be unlit. The daughter stands beside her mother, and both consider a piece of needlework; it seems that the mother is giving the young girl some instruction. Whether she is showing her daughter a creation of her own, or examining the work of the child, we cannot tell.

In front of them sits a large swift (an expanding reel), which holds yarn that has presumably been spun by someone in the household; next to the mother is a sewing box with several sewing implements stuck into its pincushion top. A little dog, a symbol of constancy and devotion, lies next to the woman. Both mother and child are intent on the piece of needlework, which they examine closely. Light shines on them both, emphasizing the close relationship between mother and daughter, and celebrating the virtues of domesticity and close-knit family life.

Madame de Pompadour

Madame de Pompadour, who was born Jeanne Antoinette Poisson (*poisson* means 'fish' in French) and was of humble origin, became the mistress of Louis xv of France. She was highly influential at court, and was a lavish patron of the arts. She entertained such men of letters as Voltaire, Jean-Jacques Rousseau, and Baron de Montesquieu, and was responsible for the appointment of many of the ministers under Louis xv. Her influence on the king was such that she was considered by many the de facto ruler of France.

The painting by François-Hubert Drouais shows a middle-aged (she died aged forty-one) Mme de Pompadour seated at her embroidery frame, a beautifully carved and painted piece of furniture. Her magnificent gown billows out around her; it is richly embroidered with flowers and trimmed with lavish amounts of lace at the hem and the cuffs. A lace kerchief covers her head. She is surrounded by elegant furniture: an ornately carved Baroque bookcase behind her reflects her erudition and literary pursuits. She is seated on an equally elaborate love seat. On her left is placed an opulent sewing table, which is well equipped with tools, and embellished with ivory medallions.

A small black dog, a symbol of devotion—in this case her devotion to the king—hops on a chair to attract her attention.

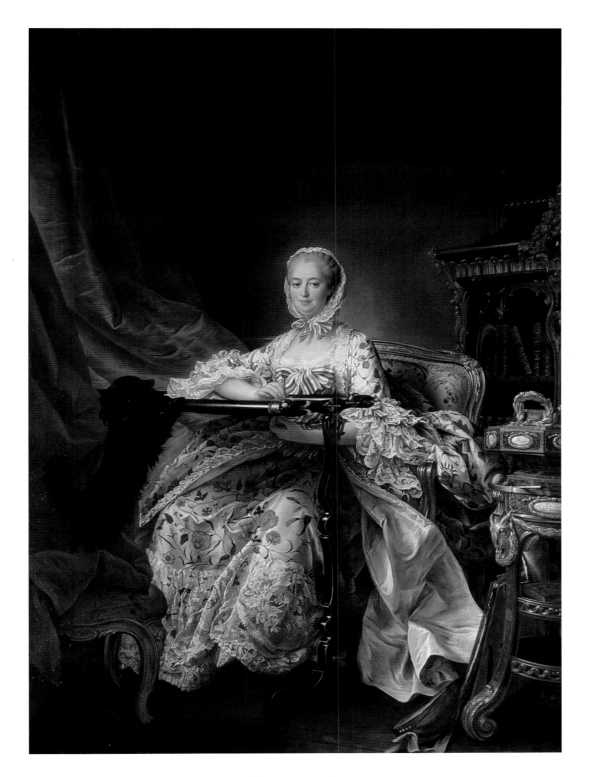

François-Hubert Drouais, 1727–1775
Madame de Pompadour, 1763–64
THE NATIONAL GALLERY, LONDON

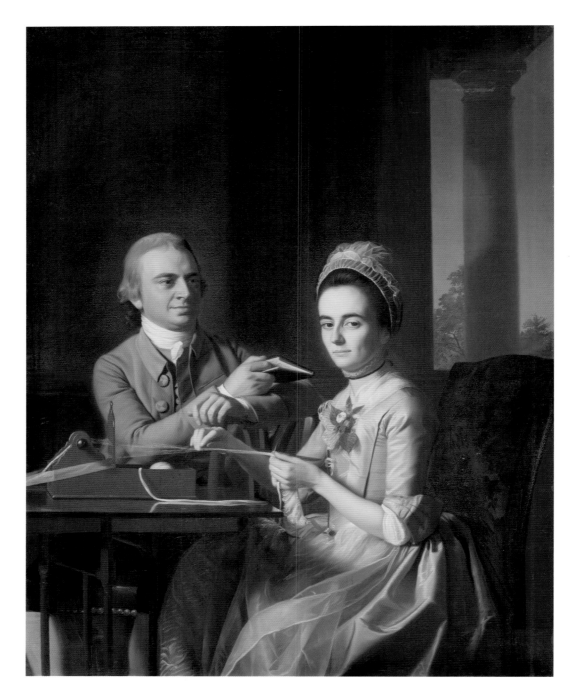

John Singleton Copley, 1738–1815
Mr. and Mrs. Thomas Mifflin, 1773
PHILADELPHIA MUSEUM OF ART

Mr. and Mrs. Thomas Mifflin

John Singleton Copley is rightfully called the first great American painter, and he is widely known for his honest portraits of the wealthy colonists in pre-Revolutionary Massachusetts. Most Americans are familiar with Copley's portrait of Paul Revere (1768–70, Museum of Fine Arts, Boston). He painted the famous silversmith in his work clothes, with the object of his labors in his hand, and his tools on display. This was a very unconventional style for the time, when the English aristocracy (which, of course, included the colonists) would be horrified to be seen "working." Copley was an ardent Loyalist and, when the fledgling United States defeated the British in the Revolutionary War, he moved to England, where he continued his painting career, greatly influenced by Joshua Reynolds, Thomas Gainsborough, and Benjamin West.

Copley did not glorify or flatter his subjects, but rather painted a true representation of them. His renditions of clothing, particularly the elegant fabrics worn by the women are extraordinary in their detail, beauty, and accuracy.

In this double portrait of Mr. and Mrs. Thomas Mifflin, Copley has portrayed a prosperous Philadelphia couple. Mr. Mifflin was the aide-de-camp for George Washington during the Revolutionary War, and he later became governor of Pennsylvania.[1]

In this painting Mrs. Mifflin is working on a small loom using a technique called "knotting" (a technique somewhat akin to macramé). It was a popular pastime for bourgeois women in the colonies, and a painting like this would indicate that Mrs. Mifflin was affluent, with time to spend on leisure activities. She is dressed in a beautiful beige gown made of a shiny fabric, possibly silk, with organza trim. A cap of the same sheer fabric contains her hair, and she looks at us with a solemn gaze, although a hint of humor is apparent in her mouth. Her husband appears proud of his accomplished wife. He holds a letter in his hand, but seems to point it directly at her, drawing our attention to the object of his admiration.

This is a successful couple, who appear content with their circumstance in life. There is little else in the painting, except for the fine table on which the loom rests and the two columns in the background, suggesting substantial living quarters.

1 Helen Dore, *The Art of Portraits*, London (Shooting Star Press) 1994, p. 44.

The Ladies Waldegrave

Joshua Reynolds, the leading English portraitist of his day, was commissioned to paint the three young Waldegrave nieces of Horace Walpole, a patron who was known to be a great admirer of embroidery in general, and of tambour work in particular, which the sisters are here engaged in. Tambour work was highly fashionable in the eighteenth century, on both sides of the Atlantic. Its delicate lines and curlicues, vines and tendrils were widely employed to decorate clothing and such domestic items as curtains and household linen.

The Waldegrave sisters were quite young, aged eighteen, nineteen, and twenty-one, when this painting was executed, but at the time powdered hair was fashionable, even at that age. By contemporary standards it ages them dramatically. All three sisters are clad in cream muslin gowns, which are trimmed with lace, suggesting to us the family's elevated place in society. The dresses all have deep décolletages, allowing the sisters' milk-white bosoms to be admired. The powdered hair and the muslin gowns create a symphony in white, with only the girls' rouged cheeks offering a hint of color.

The sisters crowd around a small inlaid table, on which are placed an elaborate sewing bag, a book, and a pair of scissors. They are seated on red velvet chairs, and red drapes form a backdrop to the scene, both of which create a strong contrast to the figures in white. The only other element of the painting is a small open window to the upper right. Most stitchers of this era before artificial light had to sit near a window to see their needlework. They are posed as the Three Graces, but Reynolds broke with the convention in picturing them with their embroidery. No doubt this was done to accommodate his patron, but it was quite a departure for Reynolds to show three upper-class young women engaged in such an activity. Nevertheless, this is a charming and appealing portrait, offering a glimpse of life in the eighteenth century.

Lady Hortensia Waldegrave is depicted with her tambour hook as she leans over the large round tambour frame from which this technique derives its name. Lady Maria sits opposite her, holding a skein of silk, which Lady Laura, the eldest, winds on to a card.[1] Tambour embroidery is worked with an implement resembling a crochet hook, and the actual stitching is similar to the chain stitch. Young girls of marriageable age often posed with their tambour work because it allowed them to assume a graceful pose, and thereby be attractive to eligible men. There exists another very similar painting by the American portrait painter Gilbert Stuart, *Mrs. Dick and her Cousin Miss Foster* (private collection), which also portrays two young girls in white with their tambour work, thus suggesting that this convention was practiced in both England and America.

1 Thomasina Beck, *The Embroiderer's Story: Needlework from the Renaissance to the Present Day*, Newton Abbot, Devon, UK (David & Charles) 1995, p. 86.

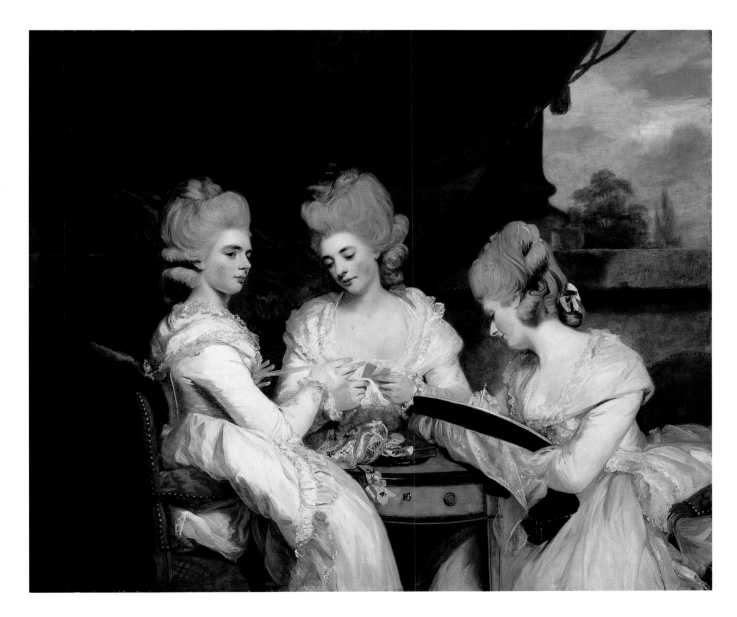

Joshua Reynolds, 1598–1664
The Ladies Waldegrave, c. 1780
NATIONAL GALLERY OF SCOTLAND, EDINBURGH

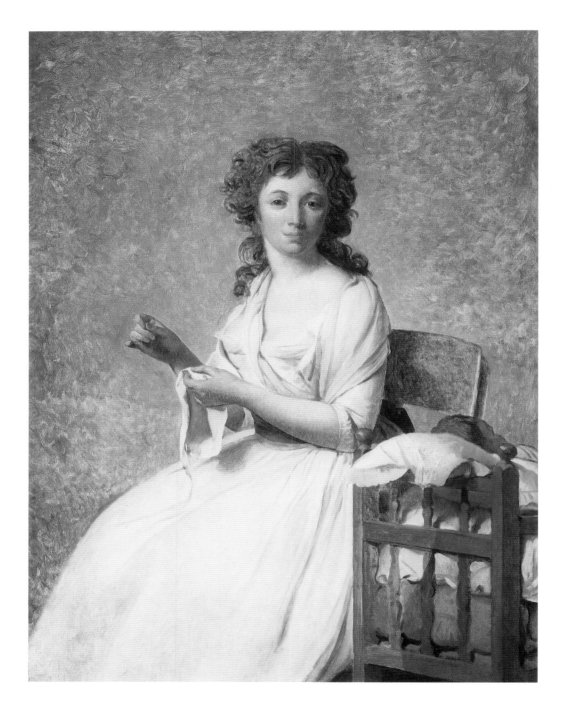

Jacques-Louis David, 1748–1825

Madame de Pastoret and her Son, 1791–92

THE ART INSTITUTE OF CHICAGO

Madame de Pastoret and her Son

Jacques-Louis David was a great French Neo-classical painter during and following the French Revolution. He is regarded as the painter of the Revolution, his paintings often making political statements, but he is also known for his outstanding portraits of the genteel upper classes, particularly those of women.

In this painting, David has portrayed Mme Adelaide de Pastoret sitting at the side of her newborn son. She so dominates the painting that only close examination reveals the cradle and sleeping child within. She is clothed in a simple muslin gown, with a low décolletage, designed to facilitate the nursing of a child.

At a time when wealthy women gave their children to wet nurses to raise for the first year of life, it may be that, in this painting, the de Pastorets and possibly David, too, are making a statement about the family's progressive leanings. Otherwise remarkable is what the mother is not wearing: she displays no jewelry, not even a wedding ring. Furthermore, she is clad in the simplest of gowns made of plain fabrics, with no lace trim, no pleating, no ruching, no frills or furbelows. In the early 1790s, in the wake of the French Revolution of 1789, the aristocracy were in fear of their lives, and their attempts to downplay their wealth is reflected in the mother's attire.

The baby sleeps in a beautifully made cradle, of fine wood with hand-turned finials, and the bed seems to be furnished with luxury linens, including a lacy pillow slip. But, other than this suggestion of affluence, the portrait is resolutely unembellished.

Mme de Pastoret is posed with her sewing, the ideal pastime when one is tending a sleeping infant. It appears that she is making something for her son. She is not holding a needle, although the positioning of her hands certainly indicates that she is sewing. It is believed that the de Pastorets had a falling out with David because of his revolutionary political activities, and so the painting was never completed. Besides the absence of the needle, the background is also unfinished.

Catherine Brass Yates
(Mrs. Richard Yates)

Catherine Brass Yates was the wife of wealthy New York importer Richard Yates, and both of them chose to be painted by the mercurial portraitist Gilbert Stuart, who is best known for his many depictions of George Washington. Stuart is also responsible for capturing on canvas many of the founding fathers and other prominent people of late eighteenth-century America.

Mrs. Yates wears a cream dress with a voluminous organdy collar. Her bonnet is a high-crowned pouffe with lace edging, with a shiny satin ribbon around her head. She is seated on a red chair ornamented with decorative upholstery nails, the only other item in this portrait. Mrs. Yates holds up her right hand in preparation for taking the next stitch, and one can discern the glint of a thimble on her middle finger. Her face shows the passage of years, and her eyes regard us with a sardonic gaze. The artist does not seek to beautify her. He does not shorten her pointed nose, he gives a hint of a mustache on her upper lip, and her right eyelid appears to sag a bit. She is slender and spare, a shape that was not popular then. She sits with her back perfectly straight, perhaps indicating a disciplined life.

One might wonder why this wealthy woman is portrayed with her needlework. This is unusual for the time, but American painters were beginning to portray their subjects with symbols of their occupations or interests. Perhaps this was a reaction to the traditions among English nobility, where the upper classes were never to be acknowledged as "working" or actually using their hands.

One may surmise that Mrs. Yates was well known for her prowess in embroidery, and her portrait sought to reflect that. She certainly appears to be a woman without pretension; her clothing is of high quality but is not overly decorated with frills and trimmings. Perhaps she was loathe to be idle, to waste time, even while sitting for her portrait. It is a testimony to her self-confidence that she would be so posed.

The looseness of style in the handling of the play of light on the fabrics illustrates a significant development in painting technique that would eventually be taken up by the Impressionists seventy-five years later.

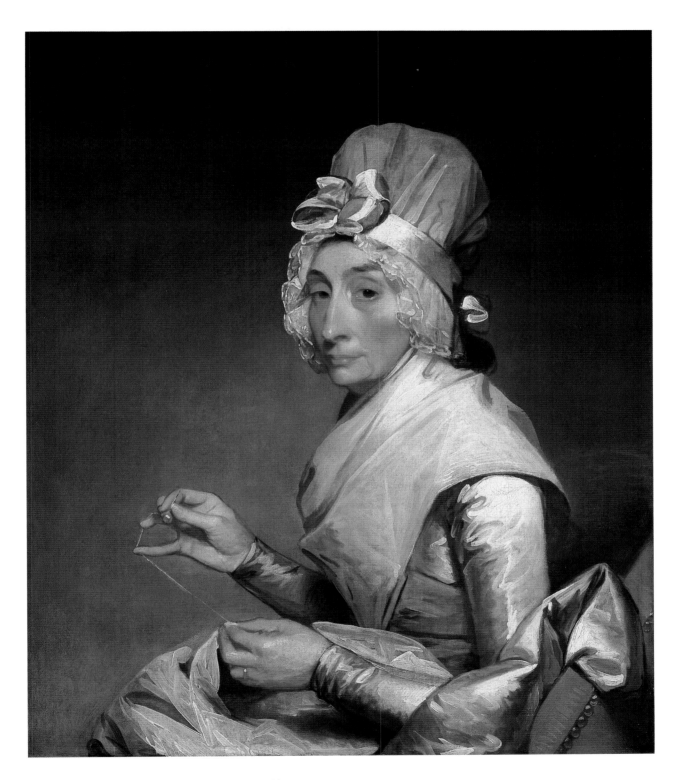

Gilbert Stuart, 1755–1828
Catherine Brass Yates (Mrs. Richard Yates), 1793–94
NATIONAL GALLERY OF ART, WASHINGTON, D.C.

Kitchen Interior
(Intérieur d'une cuisine)

This genre painting by the French painter Martin Drolling gives a glimpse into the life and living arrangements of early nineteenth-century Europeans. Compared with today's temples of food, the kitchen of two hundred years ago as represented here was humble indeed. It is even possible that this was a separate building from the main part of the home; the kitchen as an outbuilding was a device to prevent fire spreading to the living quarters, and to keep cooking odors well away from the parlors and reception halls.

In this painting, the utensils sit on open shelves. Pots hang from pegs and hooks, bowls and pitchers sit about in convenient locations, brooms and dusters are easily accessible. And yet there are some similarities to today's kitchens. Herbs have been hung on the wall to dry, and many utensils and vessels are the same as those we use today, although few of us do our cooking in fireplaces.

Here two women, neatly clad, relax from the labors of the day with additional work, but at least they can sit down and chat while they do it. Both work on sewing household articles, it seems, and have turned to look at the artist. On the the floor between them sits a young child who plays with a kitten, her doll discarded in favor of the more lively distraction.

It is possible that the woman in the foreground is the lady of the house, for she is more elegantly dressed, with long sleeves that would inhibit any kind of hard or dirty work; she wears a fancy cap on her head, and has a rather elaborate ruffle at her neck. Her sewing, too, is a bright color, indeed, the only bright object in the whole composition, except for the light pouring in from the outside. The artist intends us to notice the red cloth, and the woman working on it.

Working on the sewing was no doubt a pleasant interlude for both mistress and servant, a chance for them to rest from harder labors, and an opportunity for them to interact.

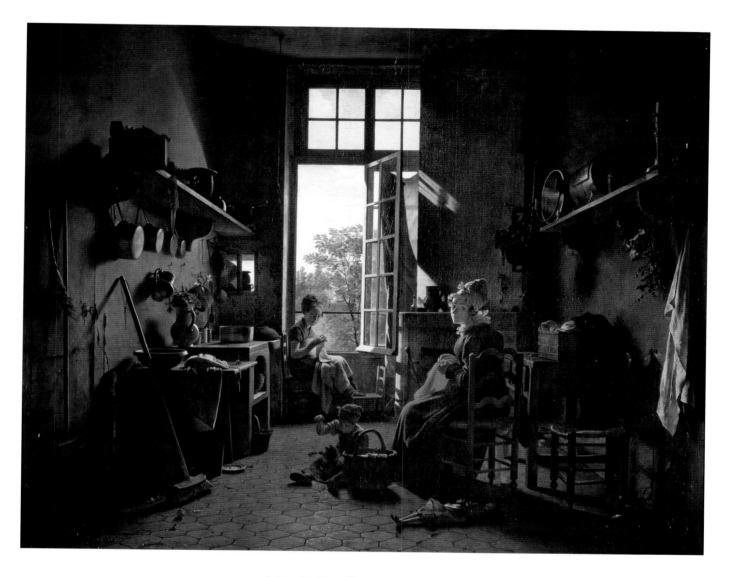

Martin Drolling, 1752–1817
Kitchen Interior, 1815
(*Intérieur d'une cuisine*)
LOUVRE, PARIS

The Lacemaker

The Russian artist Vassily Andreyevich Tropinin has created his own version of *The Lacemaker*, with the influences of Vermeer readily apparent (see pp. 26–27). Tropinin's model is viewed from slightly below, as is that in Vermeer's painting, and the emphasis is on her hands and her work. There is palpable tension in her fingers, especially those of her right hand as she pinches one of the threads. Numerous bobbins, the tools of the craft, cascade from the left side of the piece in progress, and they are prominent at the center of the painting. The lacemaker is also shown with light falling on her smooth forehead and cheek, a similar effect to that in the Vermeer painting.

There is little to distract us from the lacemaker and her work; all the emphasis is on her. Except for the stand and table that support the lace and the pillow, there is nothing to give us any clues as to the location or social situation of the model. There are scissors on the lacemaking table, and one might only later notice a lacy edge on the cloth that protects her work. In fact, this white cloth is the brightest element of the painting, with its intensity and shape directing the eye to the bobbins.

The lacemaker herself wears a simple dress of an indeterminate color, which has a wide, scarf-like cream collar. Her hair is gathered back, with small curls softening her look. Her glance is rather flirtatious as she makes eye contact with the viewer, and a half-smile plays across her lips. She is attractive, well groomed, and obviously more of an artisan than a fine lady.

This painting has a companion work featuring another woman of very similar appearance and apparel, who is working on elaborate gold embroidery. Tropinin probably intended the pair of paintings to be a salute to beautiful handwork.

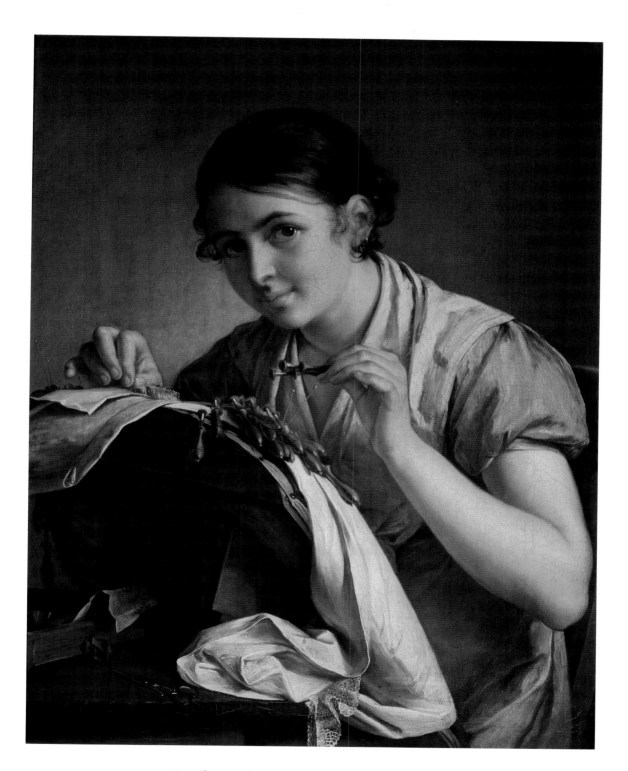

Vassily Andreyevich Tropinin, 1776–1857
The Lacemaker, 1823
TRET'YAKOV GALLERY, MOSCOW

Viennese House Garden
(Wiener Hausgarten)

Dominating this rather dark painting is a cream-colored house, located in Vienna, according to the title. The exterior is plastered with stucco, a common building material in that part of the world, and it appears that an addition is under construction. This may be a hayloft, but there seems to be a pile of lumber on the upper storey. The house is quite plain: there are no shutters or decorative flourishes on the exterior; even simple curtains are lacking at the windows.

However, the adjoining garden is overflowing with greenery, and the giant plantings appear to grow unchecked. Easily identifiable at the right of the scene are some sunflowers, fully in bloom and ready to disperse their seeds. Some small red and white flowers grow around this giant blossoming stalk.

On close inspection, a woman is visible, sitting at the lower left. Her dress is gray and she wears a sheer bonnet to shade her face, and a pink rose at her neck. She is not idle; not only is she knitting a white sock with her four double-pointed needles, but at the same time she reads from what is probably a Bible, judging by its size, the gold-edged pages, and the large, imposing lock on the cover. The artist depicts this hausfrau busily knitting, while allowing her the pleasure of a quiet afternoon in the garden.

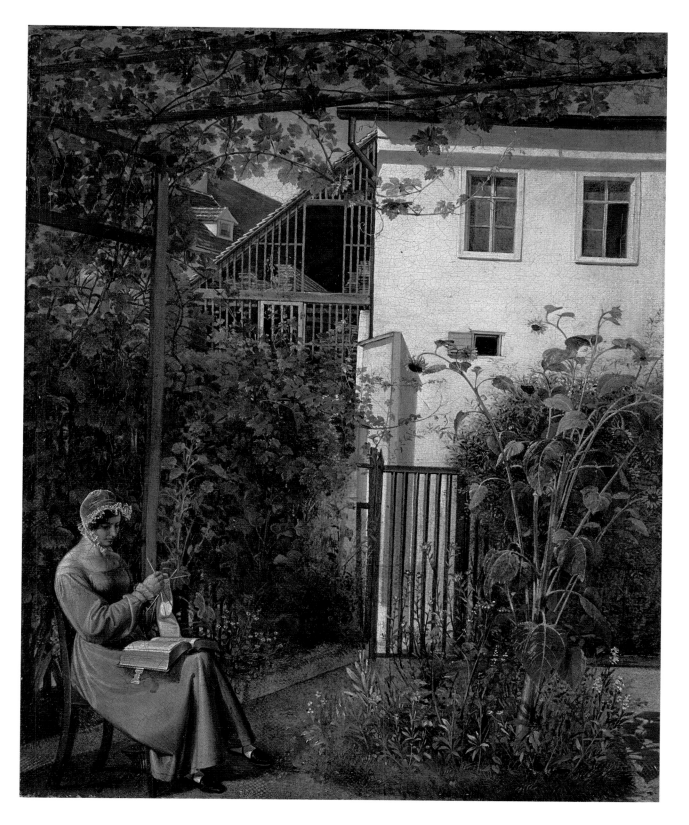

Erasmus Ritter von Engert, 1796–1871
Viennese House Garden, 1828–30
(Wiener Hausgarten)
NATIONALGALERIE, STAATLICHE MUSEEN ZU BERLIN

Rigolette Seeking to Distract Herself during the Absence of Germain

In this painting, the artist Joseph Court has depicted Rigolette, a character in the novel *Les Mystères de Paris* (1842–43) by Eugène Sue. The book was one of the most widely read melodramatic novels in France at the time. It describes life among the middle and lower classes in the bohemian slums of nineteenth-century Paris. Sue reveals much of the immorality that exists in this life; indeed *Les Mystères* is almost a crime series. Rigolette, however, is a shining example of noble virtue among the dregs of society. She is what was known at the time as a *grisette*, one of the young working-class women, normally seamstresses, who came to Paris to find work. They often lived on their own and supported themselves, and sometimes their families, on their earnings. They were, in general, uninhibited by the mores of bourgeois society and much less encumbered by society's expectations than their upper-class sisters.

Rigolette was a seamstress and was thereby able to earn her own living. Here Court has shown her attractively, but not extravagantly, garbed, and she wears on her head a small triangular scarf, made from fine lacy knitting. Indeed, in some languages Rigolette's name refers to this type of headwear. She is sitting on what appears to be a needlepoint chair, and rests her hands on a table, on which sewing implements are placed. As is often the case in such paintings, the needlewoman is placed in front of a window, which allows the artist to depict the play of light on her figure. On the windowsill we see some flowers, possibly daisies, and beyond the window a Parisian street.

Rigolette appears to be making a shirt, or some fine lingerie, and one can tell by the position of her hands that her stitches are small and even. Above her head is a birdcage that contains two birds; in the nineteenth century this often symbolized virginity and probably alludes to Rigolette's situation. The subject looks to one side, as if interrupted in her sewing. Her face is beautiful, but there is a sadness about her eyes and mouth.

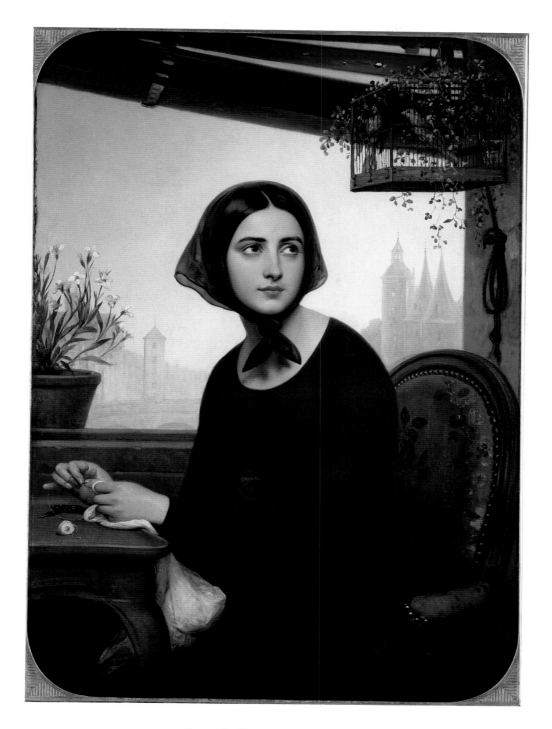

Joseph Court, 1797–1865
*Rigolette Seeking to Distract Herself
during the Absence of Germain*, 1844
MUSÉE DES BEAUX-ARTS, ROUEN, FRANCE

The Girlhood of Mary Virgin

This painting is an unusual representation of a young Virgin Mary, because in it she is shown at her embroidery, rather than reading. Mary was customarily depicted reading, for the book was an early symbol of Judaism. The Romans called the Jews the "People of the Book," but that phrase did not refer to the Bible, as might be expected; instead it alluded to the widespread literacy among the Hebrews during Roman times. The Romans were astounded to discover that even children as young as three were learning to read, in an era when many Romans were illiterate.

Dante Gabriel Rossetti himself remarked that he chose to portray Mary at her sewing because to show her reading would be incompatible with his times, when demure girls were expected to be adept with the needle, rather than with literature. Nineteenth-century art patrons would have understood this.

Rossetti was a poet as well as an artist, and he wrote two sonnets to accompany this painting. The sonnets explain the symbols that dominate this work. Mary sits at her embroidery frame, next to her mother, St. Anne, who is giving her instruction in needlework. St. Joachim is outdoors, working with the vines. A small angel stands in front of Mary, holding the lily that she embroiders; he is intended to be a precursor of the future heavenly visitor, the Angel Gabriel.

Symbols are everywhere in this picture. The lily speaks of purity, the dove represents the Holy Spirit that shall overshadow Mary. There is a cross in the latticework in the background, and the vines climbing on it are symbolic of truth. The red cloth near the cross denotes Christ's passion, as do the thorns on the branch lying on the floor at Mary's feet. There are also palms at her feet, prefiguring Christ's triumphal entry into Jerusalem. The lamp on the windowsill is for piety and the rose next to it is a common symbol of Mary. The books in the picture represent the virtues, the names of which are written on the spines.

Rossetti used as models his own mother for St. Anne, and his sister, the poet Christina Rossetti, for Mary. *The Girlhood of Mary Virgin* was the first of Rossetti's paintings to be exhibited, and the first bearing the Pre-Raphaelite Brotherhood initials. The PRB was a group of English artists that included Rossetti, William Holman Hunt, and John Everett Millais. They composed a reform movement that rejected the artistic styles from Raphael forward, and wished to return to the sincerity and simplicity of early Italian painters, in other words, before the time of Raphael.

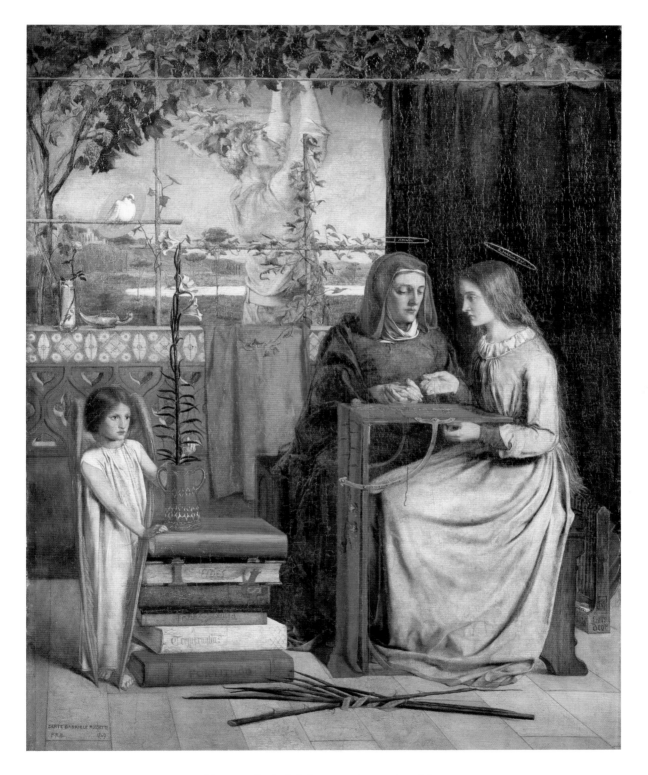

Dante Gabriel Rossetti, 1828–1882

The Girlhood of Mary Virgin, 1849

TATE BRITAIN, LONDON

Mariana

Millais's *Mariana* was inspired by Tennyson's haunting poem *Mariana* (1857), in which each verse ends with this tormented refrain:

> She only said, "My life is dreary,
> He cometh not," she said;
> She said, "I am aweary, aweary,
> I wish that I were dead!"

Tennyson's poem refers to the phrase "Mariana in the moated grange," used in Shakespeare's play *Measure for Measure*. Tennyson develops the idea of Mariana waiting and watching for a lover who does not come.

This state of passivity and being trapped in the house reflects the condition of women of the middle and upper classes in England. Released from the responsibility of sewing to provide clothing and other textiles for the family by the inventions of the Industrial Revolution, eighteenth- and nineteenth-century women were expected to do needlework as a leisure activity. Largely confined to their homes, these women were often bored and alone, and needlework was believed to offer them stimulation and consolation. The plight of Mariana would thus have been readily recognizable to women of that period.

Millais's Mariana stands in front of her needlework frame, which contains an almost completed project that is no longer enough to fill her solitary days. She stretches with ennui and erotic tension, waiting for something of interest in her life, although no man is about to appear. In spite of her sumptuous surroundings, it appears that malaise has overtaken her; she is unaware of the dead leaves that have blown into the room, that the altar is unattended, and of a mouse scurrying by. No matter how one appreciates her embroidery, hers is not a complete and fulfilled life.

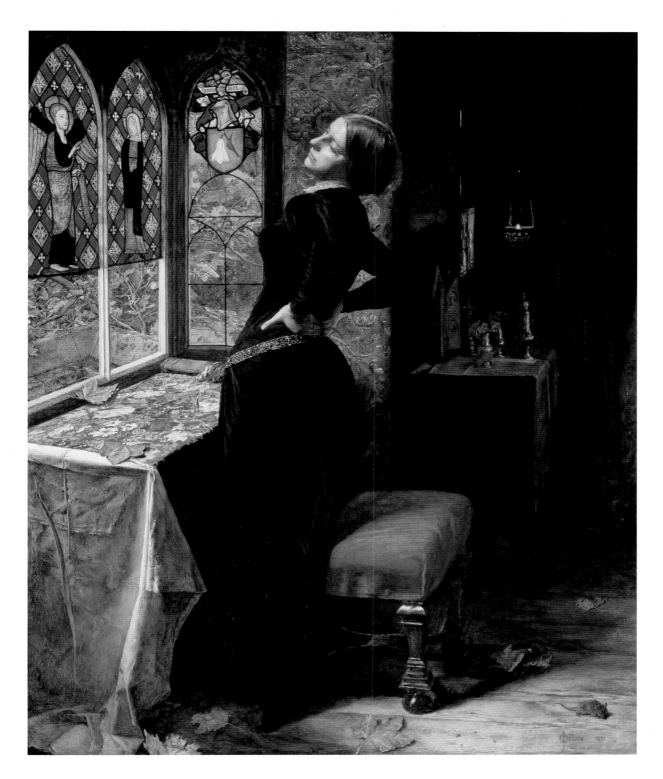

John Everett Millais, 1829–1896

Mariana, 1851

TATE BRITAIN, LONDON

The Artist's Family

The Artist's Family is a typical family scene in mid-nineteenth-century France, in which Léon Bonnat has depicted his mother and brother and sister absorbed in their evening activities.

Bonnat's younger brother, Paul, concentrates on a book, his head propped on his hand, and a serious look on his face. He wears a dark suit with white at the neck, which is probably his school uniform. He is seated at a simple round table.

Mme Bonnat is plainly garbed in a black gown with long sleeves and just a hint of a white collar. Her hair is pulled back from her serious face. The only "ornament" at all is her thimble. Her sewing appears to be of the plain sort, an undergarment or perhaps a pillow case. There is no indication that she is engaged in needlework as a purely artistic pursuit.

The little sister's clothing relieves the starkness of the scene to some extent. Her white pinafore has scallops along the hem, sleeves, and neckline, and the scallops appear to be embellished with eyelet embroidery. Her dress is black, however, an unusual choice for so young a child. It is possible the family is in mourning. The young Marie is also on her way to becoming an accomplished needlewoman. She earnestly threads her needle; her sewing lies on the low table before her. Light illuminates her pretty face; she is the most sensitively painted of anyone in the group.

Hidden in the background shadows is another woman; her apron and cap suggest she is a household servant. It was not uncommon for valued servants to be included in family portraits.

Little of interest decorates this somber room; there is no wallpaper or patterned rug; no paintings hang on the walls. We are not afforded a view out of a window. Bonnat has recorded the appearance of his family, and portrayed them as virtuous and diligent; this painting gives no further clue as to their lives.

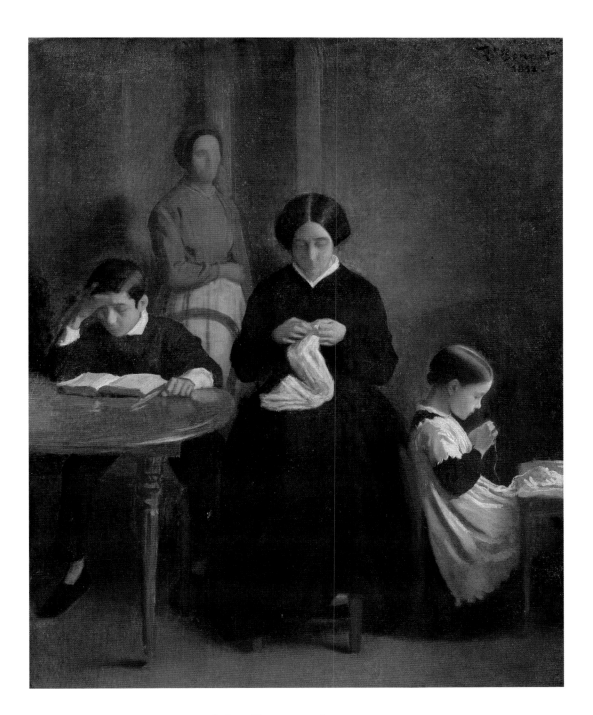

Léon Bonnat, 1833–1922

The Artist's Family, 1853

MUSÉE BONNAT, BAYONNE, FRANCE

The Secret

In this painting, a little girl whispers in the ear of her older sibling. We can only guess what the secret is.

The girls are located in a small room, judging by the size of the love seat on which they sit. The walls are richly paneled with a dark-stained wood, and a leaded-glass window allows some light in on the scene. A small bouquet in a vase on a tiny round table adds some cheer. The artist has employed touches of red to enliven the darkness of the walls, in the flowers, the pillows, the sash of the younger child, the bow around the cat's neck, and the decorative chest at the lower right.

Light floods in on the younger child; with her white pinafore and blond curls she is the focus of the scene. But it is her sister who turns her gaze to the viewer; she appears indulgent of the whims of the younger girl, even though she is obviously more mature. This older girl is dressed in a more sober style, with her dark dress and black stockings. The white lace collar and cuffs relieve the severity of her gown, and a small locket hangs from a ribbon at her neck.

Unusually in such paintings, her embroidery is depicted in some detail. The stitcher is working a panel of crewel embroidery; such panels were commonly used for window drapery or bed hangings, and she has already completed quite a large area of work. One can ascertain that her designs are Jacobean crewel, but the motifs are more widely spaced, so this must be in a more recent style. The girl sits with needle poised to take the next stitch, but she stops her work to respond to her sister.

This is a sentimental painting of children, the kind that was popular at the beginning of the twentieth century, which the middle classes used to decorate their homes.

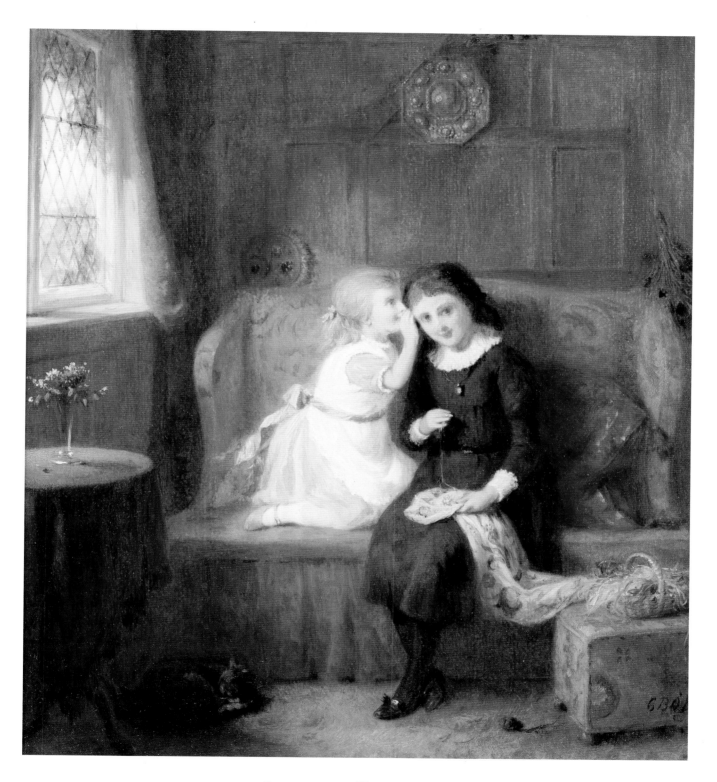

George O'Neill, 1828–1917

The Secret, 1854

EATON GALLERY, LONDON

Portrait of M. and Mme August Manet

Manet's sensitive rendering of his middle-aged parents reveals much about the life of the Parisian bourgeoisie of mid-nineteenth-century Second Empire France under the rule of Napoleon III. Although educated and respectable, the family had many constraints upon it regarding behavior and society's expectations.

Here M. Manet appears aging and ill for a man in his sixties; indeed, he lived only another two years after this painting was completed. The black clothing and the beard are typical of the period, and his serious expression is one commonly adopted in contemporary portraits.

Mme Manet wears an elegant black gown with voluminous white sleeves and a small, demure white collar. Her white lace cap reflects the family's prosperity, as lace was expensive. She also wears a large brooch at her collar, and a heavy wedding band on her left hand. On this same hand she has some sort of brace, a device familiar to needleworkers, who often suffer from hand ailments. The expression on the face of Mme Manet is also sober.

A note of cheer in this otherwise somber painting is the colorful basket of yarn held by Mme Manet. Her work is rolled up on a table to her left, and a small Bible lies near it, demonstrating the family's piety.

One must wonder whether stitching was sometimes one of the few bright moments in the existence of these women, with their lives so constrained by social mores. The creative process and the interaction with other women must have been a source of enjoyment and gratification in what was sometimes a rather austere life, even for the well-to-do.

The life of his parents as reflected here almost seems at cross-currents with Manet himself, who was active among the artistic circles of the day. Manet's younger brother married the elegant and socially prominent Berthe Morisot, who was herself a notable painter (see pp. 70–71, 96–97, and 106–107), but the parents seem quite removed from the exciting world of the nineteenth-century French artists.

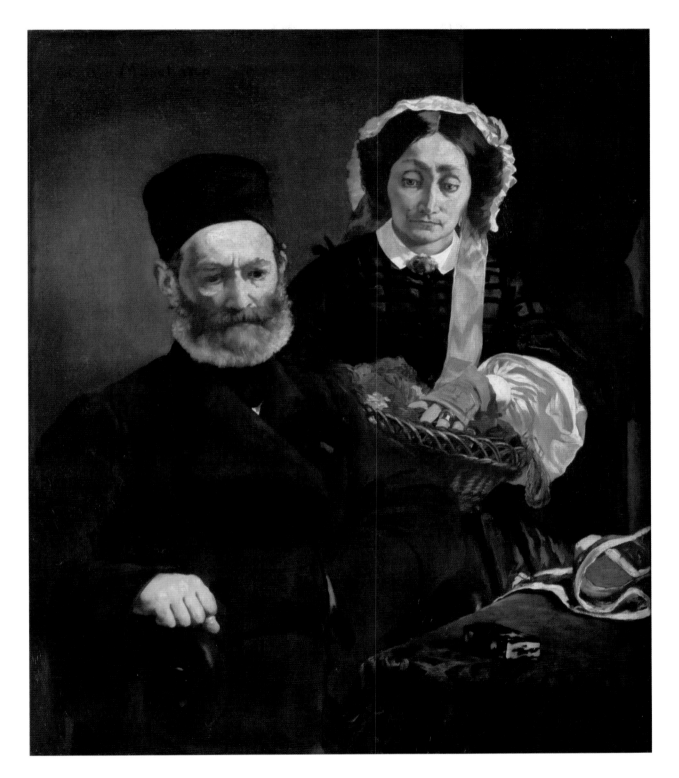

Edouard Manet, 1832–1883
Portrait of M. and Mme August Manet, 1860
MUSÉE D'ORSAY, PARIS

Coast Scene

In this genre painting by the nineteenth-century English artist Edith Hume, three young women stand at the water's edge. The sea is quite rough, and in the background a number of sailing-boats are out at sea. Clouds are gathering on the horizon, and a storm appears to be brewing in the distance. Two boats lie at rest on the beach; these are not pleasure crafts, but working boats, for this is no seaside resort.

The women are the focal point of the composition. The central figure turns her gaze to the sea; we may assume that she is anxiously awaiting her husband or lover's return. To her left a second woman is gesturing, as if to emphasize a point. She has brought with her a basket for gathering shellfish from the sand. The third young woman rests on the edge of one of the boats, and she knits a blue sock, probably for a fisherman. Perhaps she gains a modicum of comfort from this small task, its repetitive motion calming her nervous spirit.

All three are dressed in plain clothing; they wear aprons, and their hair is done up to keep it out of the way of their work. These are peasant women come to the seashore to gather crabs and mussels, but their anxiety for the safety of the men is palpable in this sensitive painting.

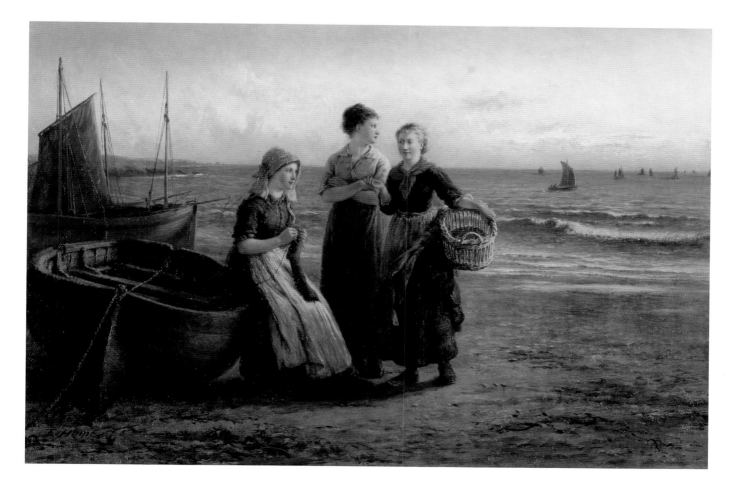

Edith Hume, 1841–1906
Coast Scene, c. 1862–92
VICTORIA AND ALBERT MUSEUM, LONDON

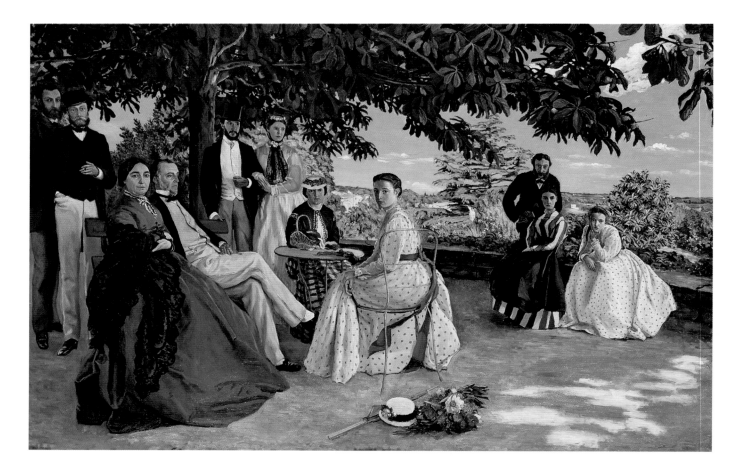

Frédéric Bazille, 1841–1870
Family Reunion, 1867
MUSÉE D'ORSAY, PARIS

Family Reunion

This large work by the French painter Frédéric Bazille has the look of a well-staged photograph. He has grouped his family members in a beautiful setting, on a large stone terrace overlooking the countryside, with a few partially hidden buildings dotting the landscape.

Most of the subjects make eye contact with the viewer, but they appear somewhat stiff and uncomfortable in their role as models. Bazille's parents sit in the left foreground; they were wealthy art patrons from the South of France, and are the ones who enabled their son not only to become an artist, but also to support some of his fellow painters, mostly notably Renoir. Mme Bazille wears a magnificent shawl of black lace; Bazille's father is impeccably garbed as a wealthy man of the day, and he gazes abstractedly into the landscape. Bazille's brother Marc perches on the low wall of the terrace; in front of him is his wife Suzanne, and to her left, a cousin, Camille des Hours. Wearing a similar patterned dress is Camille's sister, Thérèse; their mother sits across from Thérèse. Two more cousins are in the background, and Bazille himself is the tall man at the far left. His cousin Monsieur des Hours stand just in front of him.[1]

While no one is actually sewing in this portrait, there is on the table a small sewing basket, with some threads arranged as if Thérèse is choosing which to use. Once again this is the ubiquitous reference to the well-bred, accomplished women of the nineteenth century. Bazille may also have employed this device to bring some more color into the painting. Possibly Thérèse chose to bring along her needlework to pass the time during the hours of posing for this painting.

Bazille further softens the painting with a note of spontaneity: in the foreground there is a bouquet of flowers, a garden hat, and a parasol, suggesting that one of the women has just arrived to assume her role in the painting.

This painting is at once a landscape, a portrait, and a still life. Although it is painted in the Realistic style, there are hints of an Impressionist technique in the treatment of the distant foliage, and in the light glinting off Mme Bazille's gown. Bazille was just becoming recognized as a painter when the Franco–Prussian War broke out in 1870. He served in the French army and was killed at the front. Had he lived longer, his name would, no doubt, be better known among the Impressionists.

1 Melissa McQuillan, *Impressionist Portraits*, London (Thames & Hudson) 1986, p. 34.

Girl from the Megare, Sitting and Spinning
(Jeune fille de Mégare, assise et filant)

This beautiful marble statue depicts a young girl seated cross-legged on a low pedestal. Her left arm is raised above her head with distaff in hand; the right hand holds the spindle on which the yarn is spun. Her head is tilted gracefully toward the right as she keeps a careful eye on her work. The lower half of her body is draped with a cloth in the Classical manner, its folds and pleats delicately rendered. She is nude from the hips up, and her beautiful figure is in keeping with the Greek ideal. Her long hair is braided and wrapped around her head as in a garland.

It is possible that this work is an allusion to the Greek myth of the Three Fates, one of whom, Clotho, spins the Thread of Life. In the ancient Greek tradition, spinning was often a metaphor for the control that fate has over the life of an individual.

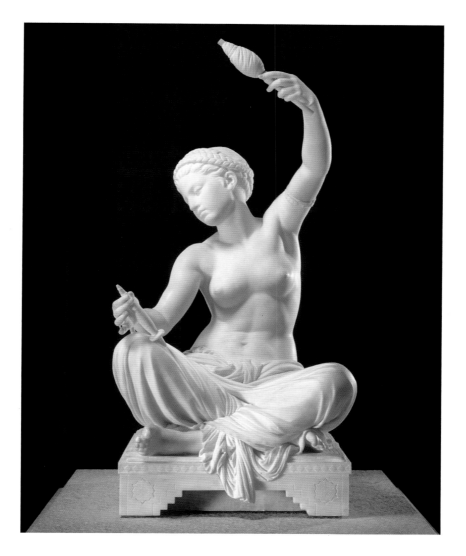

Louis-Ernest Barrias, 1841–1905
Girl from the Megare, Sitting and Spinning, 1867–70
(*Jeune fille de Mégare, assise et filant*)
MUSÉE D'ORSAY, PARIS

Young Girl at the Piano
(Jeune fille au piano)

Young Girl at the Piano, also known as *Overture to Tännhauser*, is a painting of the artist's sister and mother by the Post-Impressionist artist Paul Cézanne. This work was painted early in Cézanne's career, when his palette was somber in color. Cézanne's original title for this work was *Overture to Tännhauser*, referring to a controversial opera by the German composer Richard Wagner, on which the artist was keen.

Cézanne's sister sits at the piano; she is absorbed in her playing, with her eyes fixed resolutely on the music. She is the focus of the painting, both in her position, and in the later title of the work. The white of her dress draws our eyes to her; her dress is about the only bright object in the whole composition. Her hands appears long and thin, her neck swanlike. Her hair is tied back in a severe hairstyle.

The mother, Anne-Elizabeth, is seated behind her daughter on a dark-red sofa; her eyes are downcast as she works at her sewing. She wears a drab brown jacket over a beige skirt, and her hair is confined in the style prescribed for a married woman of the time. Her posture and demeanor suggest resignation and possibly sorrow. She sews on to a long piece of white fabric; its shape echoes the lines of her skirt, but its color reiterates the white of her daughter's dress.

This painting offers an insight into the furnishings of nineteenth-century French homes. The colors are subdued earth tones. The pattern on the slip cover on the chair to the right is continued in the border above the chair rail. The painting also reveals much about the lives of well-to-do women of this era, and the expectations society had of them. Some historians believe that music was used to dissipate tension within families, when there were few options for evening entertainment.

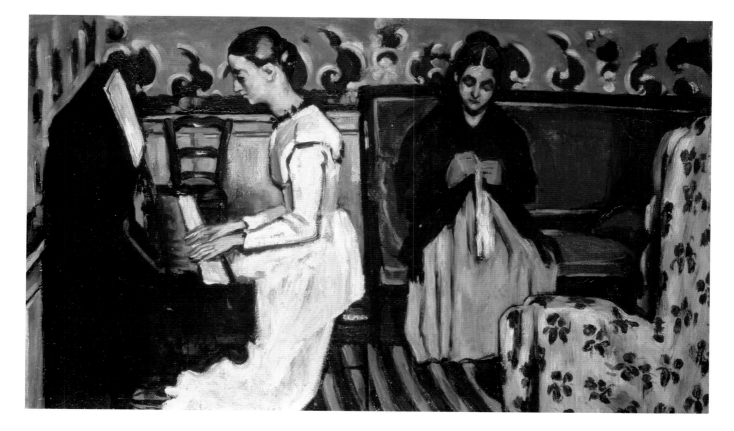

Paul Cézanne, 1839–1906
Young Girl at the Piano, 1868–69
(*Jeune fille au piano*)
STATE HERMITAGE MUSEUM, ST. PETERSBURG, RUSSIA

The Knitting Lesson

A most sensitive portrayal of a mother and her young daughter, *The Knitting Lesson* is one of dozens of "stitcher" paintings by the French Realist artist Jean-François Millet, who painted in the second half of the nineteenth century. His early work consisted of conventional mythological and anecdotal genre scenes and portraits, but from around 1850 he turned to scenes of rustic life, depicting the peasant class. He imbued these people with a dignity seldom accorded them, and it is for these scenes that he is now so well known.

There are at least three paintings by Millet called *The Knitting Lesson*. In this version, from the St. Louis Art Museum, the faces of both mother and daughter are bathed in a clear light, and both show great earnestness working on the task at hand. The young girl, surely no more than nine or ten, is intent on her project, a white wool sock that is probably for herself, judging by its size. She knits with four double-pointed needles, used for making socks, a more challenging form of knitting than the basic stockinette (stocking) stitch. The ball of yarn lies in her lap, and the yarn spilling off the ball is a bit crinkled, suggesting perhaps that she has had to unravel some work and re-knit it.

The mother is no less intent, but appears to be offering gentle advice and instruction to her daughter. She is clothed in peasant dress, with her hair covered by a kerchief, and her face is not idealized. Her left arm encircles the shoulders of her child, and with her right hand she assists in the handling of the yarn.

The child sits on a chair, which is scarcely visible, for the artist wishes us to concentrate on the people. No doubt he intends *The Knitting Lesson* as an example of family and motherly love, and the burdens that were borne even by the young in this time and place. He has introduced a few colorful notes, in the reddish tones of the mother's kerchief and the child's cap, and in the intense blue of the child's dress.

Millet's painting evokes feelings of empathy in the viewer for this mother and daughter. The girl is so young: by our standards she should be playing with her toys; and the mother looks tired. She probably spent her days in the fields, but had to find time in the evenings to help her child with her work.

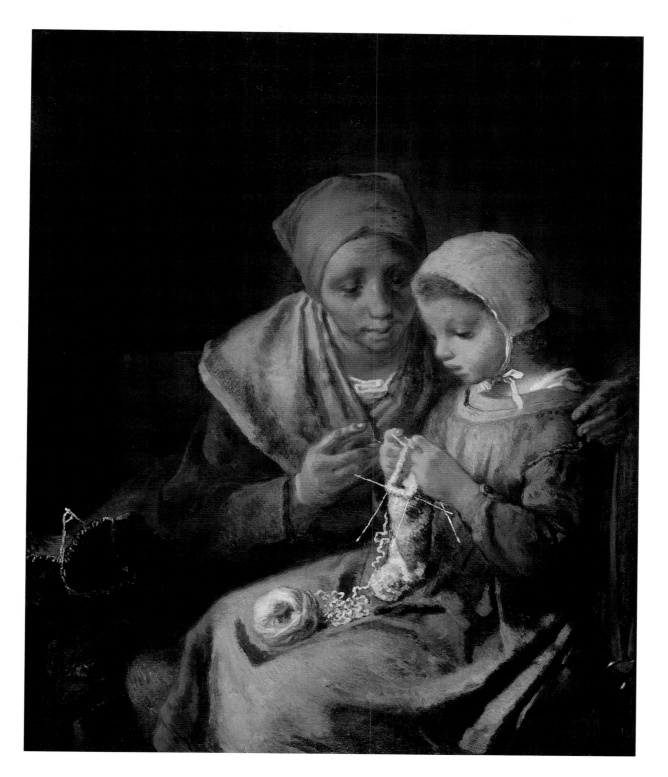

Jean-François Millet, 1814–1875

The Knitting Lesson, 1869

ST. LOUIS ART MUSEUM

The Bouquet of Marguerites
(Le Bouquet de Marguerites)

In this painting, one first notices the luxuriant bouquet of summer daisies (known as marguerites) on the broad stone windowsill. The brilliant white petals gleam in the sunlight, meticulously painted by the artist, as is the blue vase. Also prominent is a red pincushion, which holds several needles, some with thread. The orange ribbon tied to a pair of scissors cascades down the edge of the windowsill, completing the composition. A peasant girl peeks out the window from behind the bouquet of marguerites, her earnest young face half concealed in the shadows.

The painting reveals something of the restricted life of women in the nineteenth century. They were much confined to their homes, and often spent their days engaged in household tasks, which included sewing. This girl is probably a household servant, as Millet, almost without exception, limited his subject-matter to the peasants and lower classes in France. Millet was a painter of realism, and his scenes were often tinged with melancholy, as in this depiction of a girl.

The girl may be advertising her eligibility by displaying her sewing paraphernalia, as even poorer women were expected to be adept with the needle. Or perhaps the flowers indicate that she already has a love interest. She may be watching out for someone, and it is possible that the ribbon or the pincushion is a signal.

The artist's skill in painting textures is particularly apparent in this work, in the chill of the stone sill and the wood of the shutter and the window frame.

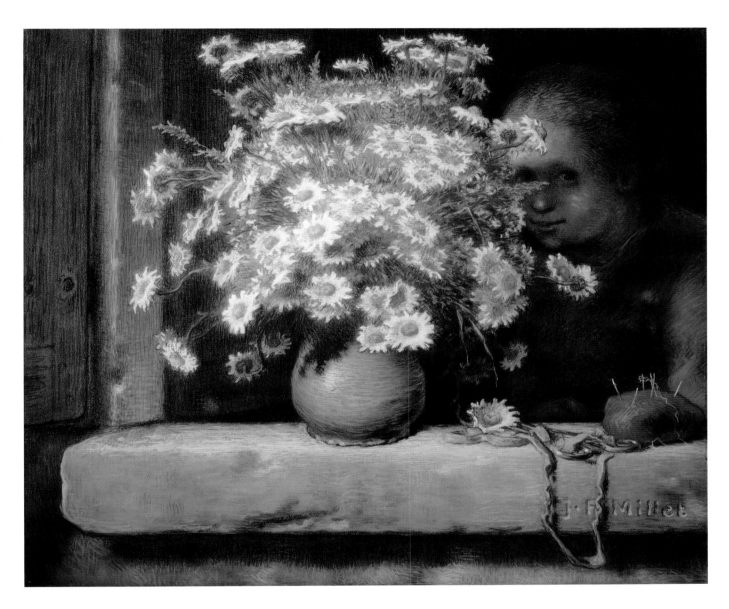

Jean-François Millet, 1814–1875

The Bouquet of Marguerites, 1871–74
(*Le Bouquet de Marguerites*)
MUSÉE D'ORSAY, PARIS

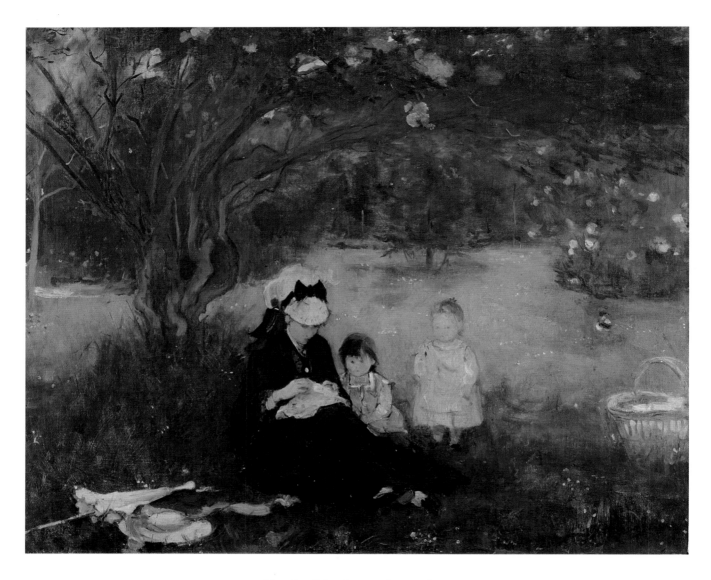

Berthe Morisot, 1841–1895
Lilacs at Maurecourt, 1874
(*Les Lilas à Maurecourt*)
PRIVATE COLLECTION, PARIS

Lilacs at Maurecourt
(Les Lilas à Maurecourt)

Berthe Morisot and her sister Edma studied painting together as young women. Edma later gave up any serious pursuit of art, when she married and became a mother. The sisters remained close, however, and spent many summers together enjoying the holidays with their daughters. Edma served as a model for numerous works by Berthe, and often their daughters figured prominently, too.

In *Lilacs at Maurecourt* Edma Pontillon is pictured accompanied by her two young daughters, Jeanne and Blanche. The setting is a lovely park, verdant green and alive with early summer flowers. The group is posed under a huge lilac tree, its pink blossoms hanging low from the branches. The lilac tree, and the roses to the right, create a frame for the three figures, surrounding them with blossoms. Edma is busy with her handwork, her head bent in the characteristic embroiderer's position. Both girls stay close to their mother, as she busies herself with her stitching. A basket of food sits at the very edge of the painting, suggesting a picnic.

Berthe Morisot has added her own presence to this painting, in the form of a straw hat and parasol that are tossed casually on the grass in the left foreground.

This painting is a consummate Morisot work, with its loose brushstrokes, appealing subject-matter, and accomplished treatment of light.

The Young Bride
(La Jeune Mariée)

Although a woman from a wealthy family in Philadelphia, Mary Cassatt lived and worked in Paris, and was one of only a handful of women accepted by the Impressionists and who exhibited with them. She retained her own personal style, however, and what she shared with them was a common interest in the everyday scene as subject-matter, rather than technique or theory. Cassatt painted women, including numerous needlewomen, and is particularly noted for her sensitive portraits of mother and child.

This painting is one of Cassatt's earliest, and is of Martha Ganloser, who was a servant of another woman artist. Mary Cassatt gave the painting to the bride as a wedding gift. The model has the youthful glow of one in love. Her flowing gown is a light red with a neckline that is covered with a piece of lace; a bit of it peeps through her sleeves as well. The lace also appears in the stocking she knits, which will no doubt be worn at her wedding. The other object depicted in the painting is the ball of yarn, which almost appears to hang in space and glows with the same light that illuminates the model.

Historians believe that Cassatt was inspired by her visit to The Netherlands to paint ordinary subjects engaged in everyday activities. Here she has chosen not a prosperous woman but a humble housekeeper. She imbues her with dignity by painting her in a gown embellished with costly lace, and showing her making an item of luxury for her own use.

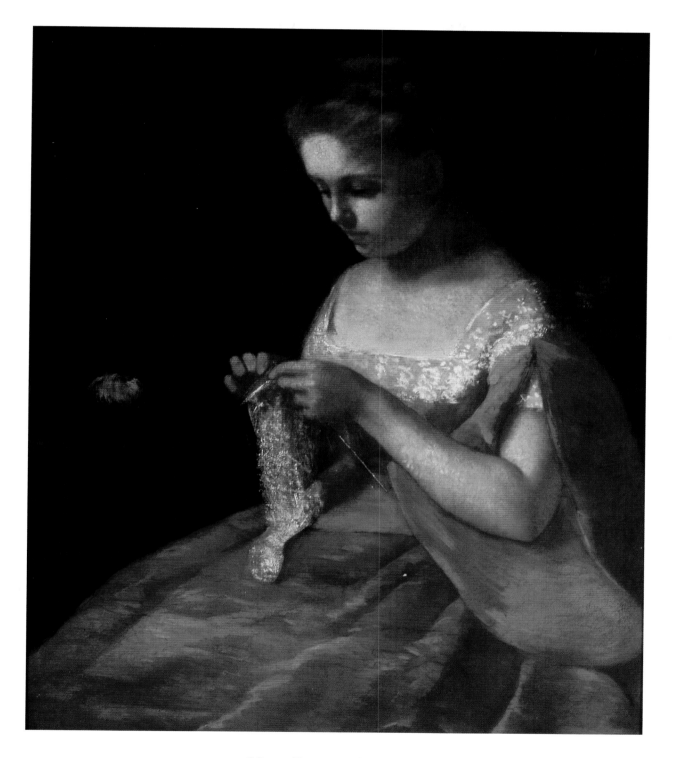

Mary Cassatt, 1844–1926
The Young Bride, 1875
(*La Jeune Mariée*)

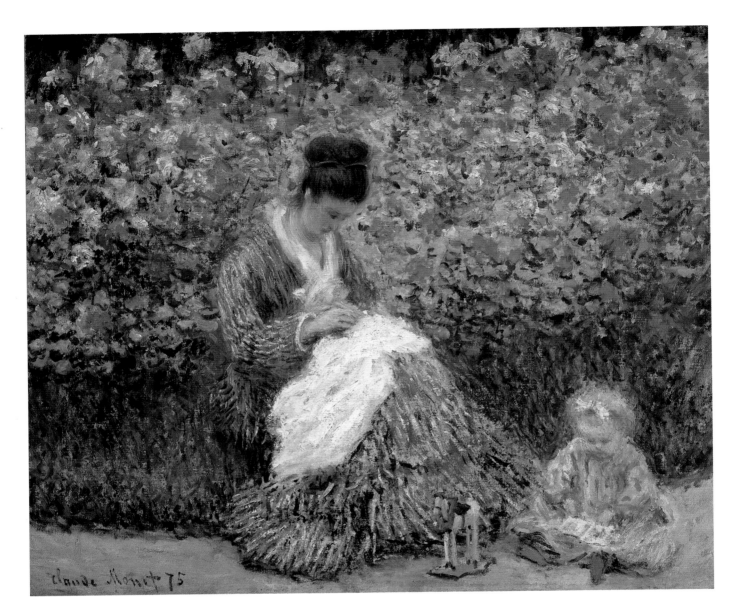

Claude Monet, 1840–1926

Camille Monet and a Child in the Artist's Garden in Argenteuil, 1875

MUSEUM OF FINE ARTS, BOSTON

Camille Monet and a Child in the Artist's Garden in Argenteuil

Claude Monet's luminous painting of Camille is popular today because of its pleasing subject-matter and its brilliant color palette. Camille is pictured here accompanied by a child, and is busy with her sewing. She wears a blue striped "day" gown that is typical of those worn by bourgeois women of that period. No doubt the selection of a blue gown was intentional, as it evokes the Virgin, and her devotion to duty is further emphasized by the fact that Camille is sewing. We know that Camille was an accomplished needlewoman, but here she appears to be working on something more utilitarian, perhaps a garment for a child.

Monet has placed Camille, whom he married the year after this painting was produced, before a background of brilliant blooms, blazing in pinks and reds interspersed with green leaves, all of which combine to set off the blue gown. The roses are another symbol of the Virgin Mary, which further emphasizes Camille's future role as the virtuous wife. The child pictured here is not Camille's son; nevertheless, this painting is a celebration of femininity and motherhood. Monet's use of dappled strokes, brilliant color, and the outdoor setting all combine to make this an archetypal Impressionist painting.

Camille was a frequent model for Monet and is often portrayed in exotic costumes. This painting gives us an idea of her real life, and of Monet's tender feelings for her.

Madame Monet Embroidering
(Camille au métier)

Claude Monet has painted his mistress Camille, whom he married in 1876, at her
needlework, but it is no mere mending or casual sewing. She sits before an embroidery
frame, with her canvas well mounted and an intent expression. This is no dilettante
embroiderer, but a serious artist. Her frame is elaborate, and no casual embroiderer
of that time would own such an item. We can surmise that she is creating a work of
art intended for framing or otherwise decorating her home. It is believed that Monet
had a high regard for Camille's embroidery, considering it analogous to his painting.

Here Camille is pictured as a woman of means, devoting her leisure time to creative
needlework. She is seated in what appears to be a sun-room; she herself is framed by
arching potted palms, the form of which is further emphasized by a second arch of the
heavy drapes. Subtly colored tiles cover the wall under the window, and a highly
patterned rug lies under her feet. This is a busy painting of different textures that
allows Monet to utilize his daubs of paint to create a dazzling effect.

Camille wears an elaborate gown, which seems to be of rich turquoise velvet enhanced
with brocade panels and trims. She was known to be a woman of fashion, and she wears
this dress in portraits by Renoir, who was a family friend.

In this painting, Camille is the typical bourgeois French woman, free of quotidian chores
but loathe to be idle. She prefers to keep her hands busy, as was expected of ladies of that
era, and she enjoys artistic self-expression. The title of the painting indicates that Monet
considers that here Camille is shown practicing her job or her craft.

Although paintings of embroiderers were popular in the nineteenth century, this painting
did not sell for a good price when it was sent to auction along with work by other
Impressionists.

Claude Monet, 1840–1926
Madame Monet Embroidering, 1875
(*Camille au métier*)
BARNES FOUNDATION, MERION, PA

Pierre-August Renoir, 1841–1919

A Young Woman Crocheting, 1875

(*Jeune femme cousant*)

STERLING AND FRANCINE CLARK ART INSTITUTE, WILLIAMSTOWN, MA

A Young Woman Crocheting
(Jeune femme cousant)

Pierre-August Renoir has portrayed one of his favorite models, Nini de Lopez, in an innocently provocative pose. Nini is busy with her crocheting; it appears that Renoir has caught her unawares between sittings for more formal portraits. Seemingly unconscious of her chemise slipping from her shoulder, Nini is absorbed in her project and does not acknowledge either the painter or the viewer.

The woman's informal apparel would lead us to assume that she is not of the upper class or the bourgeoisie; no society woman would have allowed herself to be portrayed in this manner. Her luxuriant blonde hair cascades down her back, again an informal style that no woman of the time would have worn in public. This further enhances her youth and innocent sexuality, as do her full red lips and delicate white shoulders.

Nini's crocheting appears to be lacy and therefore not utilitarian; possibly she is making something special for herself, or she may be an industrious young woman who is loathe to have her hands idle.

In the background, a framed painting or mirror is discernible, and in front of it a large, dark vase of flowers. Next to the vase is something crystal, which could be another vase. The light emanating from these objects echoes the white of the crocheting and Nini's blouse.

Renoir painted two other paintings with the same subject-matter, and another of a different woman crocheting; obviously this was a favored theme for his work.

Mihály Munkácsy, 1844–1909

A Willing Helper, c. 1875–90

GAVIN GRAHAM GALLERY, LONDON

A Willing Helper

In this painting by the Hungarian painter Munkácsy, a woman and her young daughter enjoy a relaxing moment in their conservatory. Flowers, inside and out, frame the scene. The windows have been depicted with great skill by this realist artist. One can sense the warmth of the sun streaming through the glass, and the humid air of the greenhouse.

The woman is seated on a small love seat, dressed in a casual gown for the era, with ruffles at her feet, elbows, and neck. She has paused in the act of stitching to observe her daughter, or perhaps to offer a word of advice. Her feet are on a small footstool, one leg crossed, with just a hint of shoe visible. At her side is a small, elaborate Chinese table, and on it is placed her basket of sewing supplies. She holds on her lap a canvas; Berlin work, a type of canvaswork, usually of cross stitch or tent stitch in wool, was quite popular in that era, and one might deduce that this is the nature of her embroidery.

The little girl is enthusiastically watering some nearby flowers; she holds a traditional watering can as she waters the flowers in pots on the table.

Everything about this painting proclaims a life of wealth and ease: the beautiful setting, its gracious furnishings, and its well-dressed figures. Munkácsy married a wealthy Parisian widow in his middle years, and his paintings changed from rather stark realism to what are known as salon paintings. *A Willing Helper* is a good example of the latter.

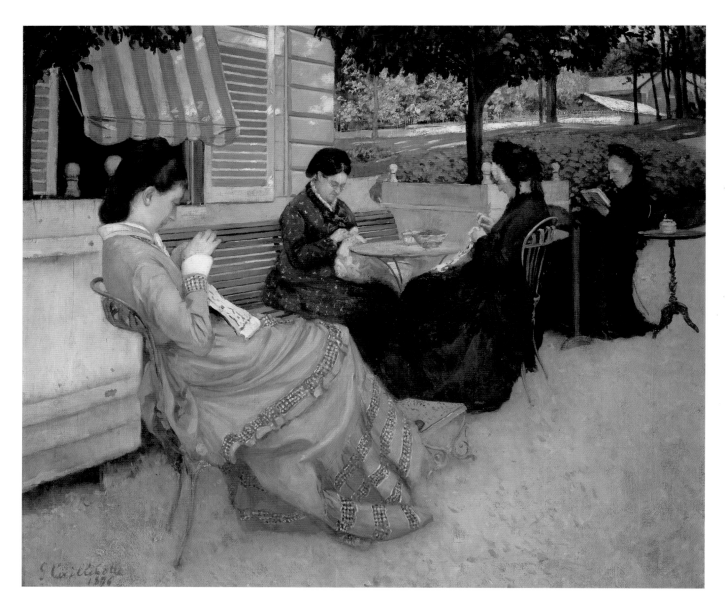

Gustave Caillebotte, 1848–1894
Portraits in the Country, 1876
(*Portraits à la campagne*)
MUSÉE BARON GÉRARD, BAYEUX, FRANCE

Portraits in the Country
(Portraits à la campagne)

This large painting by the French painter and collector Gustave Caillebotte is an unconventional portrait, in that none of the figures makes eye contact with the viewer, and their faces are scarcely visible. Three of the women are absorbed in their stitching, while in the background the artist's mother, Mme Martial Caillebotte, is reading.

In the foreground is Marie Caillebotte, a cousin of the artist; the woman to her right, in black, is her mother, Mme Charles Caillebotte. Opposite her is a family friend, Mme Hue. The women are seated outside in the shade; outdoor scenes of ordinary daily activities were favored subject-matter for Impressionist artists.

The scene is one of repose in a luxurious setting; these women relax in a meticulously landscaped yard with carefully tended flowers in the background. They are wealthy, yet still industrious; their daily needs are taken care of by servants but one senses that these disciplined souls would never allow themselves to be idle. Although two of the women wear mourning garb, the riotous red flowers in the background offer a note of hope.

The Caillebotte family were prosperous people of leisure; both men and women had time to pursue artistic endeavors. Caillebotte himself was a patron of his fellow Impressionists and, indeed, was often responsible for their survival, as he would purchase paintings from them when they were in need of funds. Eventually he too became a painter of note, and is now known as the urban Impressionist.[1]

1 *Gustave Caillebotte, Urban Impressionist*, exhib. cat. by Anne Distel *et al.*, The Art Institute of Chicago, February–May 1995.

Mary Cassatt, 1844–1926
Lydia Crocheting in the Garden at Marly, 1880
THE METROPOLITAN MUSEUM OF ART, NEW YORK

Lydia Crocheting in the Garden at Marly

Mary Cassatt established a household in Paris in the 1880s and was joined by her sister Lydia. Their parents stayed with them in Paris for some time, and occasionally their brother, a businessman from Philadelphia, also visited them. These family members became regular subjects for Mary, the aspiring painter.

Lydia suffered from Bright's disease, which affects the kidneys, and died in 1882; she was only in her early forties. Mary was devoted to her sister, and even suspended her painting to care for her in her final illness. Later, she once again abandoned her painting to care for her aging parents.

Lydia was an accomplished needlewoman, and has been painted by Mary with various types of stitching in her hands. She is pictured here in an elegant gown with elaborate trim and fashionable lace at the cuffs, which contrasts greatly with her pale face and frail-looking hands. Her face is protected by a lace bonnet. In spite of her obvious poor health, Lydia is painted outside, in a lush garden. The pathway, the russet hedge, and the line of small trees all lead the eye to the conservatory windows in the background, which with its white tones repeats the white of Lydia's bonnet.

Unlike other Cassatt garden scenes, the color palette here is somber, and the light limpid, perhaps echoing the precarious health of Mary's invalid sister.

Suzanne Sewing

This is one of Paul Gauguin's early nudes, a precursor of his later work when he moved to Tahiti in 1891. Suzanne, the model, seems perfectly content to pose in the nude, but it is slightly incongruous that she is pictured with her sewing. Perhaps even the models became restless while posing, and sewing allowed them to do something productive during this enforced idleness. The repetitive nature of stitching is calming for most people, and this may have enabled her to assume the composed posture and demeanor captured in this portrait. Needlework was also an important pastime in European life at the time, and paintings depicting it were marketable.

The lute hanging on the wall may be there to suggest refinement, either that of Suzanne or of Gauguin himself. The instrument is often used in paintings as a symbol of harmony and here it also serves to echo the female form. The curtains above reveal a glimpse of what is outside, but it is the model herself who is the focus of this painting.

Paul Gauguin, 1848–1903

Suzanne Sewing, 1880

NY CARLSBERG GLYPTOTEK, COPENHAGEN

Young Woman Sewing in a Garden
(Femme cousant)

Mary Cassatt has painted a young woman dressed in a pale-blue gown; its only ornamentation seems to be a sheer jabot (a frill on the breast of the dress) cascading from the neckline to the waist. The woman is intent on her sewing. Her pose is relaxed and her demeanor serene, although the chair does not look comfortable. The Gothic-shaped chair-back exactly follows the slope of the woman's shoulders.

The stitcher does not appear to be engaged in simple sewing, in spite of the title of the painting. It is possible that she is tatting (a form of threadwork that is worked with a specialized shuttle rather than a needle, which produces very fine designs consisting of knots and loops), or making needlelace. Whatever she is making appears small, delicate, and lacy, although we cannot be sure of its exact nature.

The woman is seated in a garden lush with red flowers, which seem to be geraniums. The foliage is dark green, suggesting she is in the shade. Behind her the sun illuminates a grassy area, more flowers, and a road sloping uphill. The complementary colors of red and green in the garden are similar in value and, although they combine to make a busy background, the figure of the stitcher nevertheless advances because her gown and complexion are of a much lighter color value.

The identity of this young woman is unknown. Cassatt's paintings are primarily of indoor scenes; *Young Woman Sewing in a Garden* is one of Cassatt's few outdoor paintings.

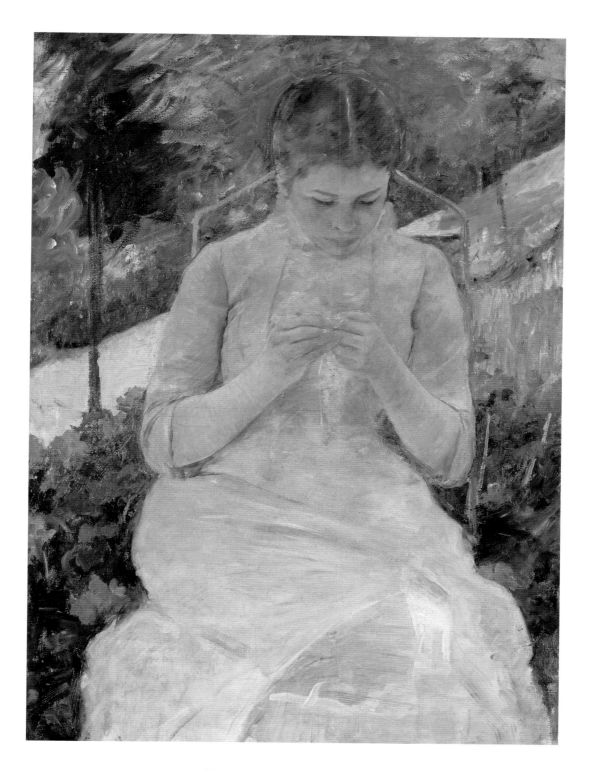

Mary Cassatt, 1844–1926
Young Woman Sewing in a Garden, c. 1880–82
(*Femme cousant*)
MUSÉE D'ORSAY, PARIS

The New Arrival

A beautiful young mother gazes lovingly at her newborn child, a daughter, judging by the pink blanket draped over the foot of the cradle. The woman holds her sewing, stopping mid-stitch to turn her attention to the sleeping child, of whom all we see is a tiny hand. The mother appears to be speaking to the child, her lips parted and her face animated. She is dressed in a white frilly gown, with puffed sleeves, a scoop neck and flounces at the hem. She wears a light green sash around her very slender waist (surprising for one who has given birth so recently), the color of which is echoed in the ribbons in her auburn hair.

We cannot detect the exact nature of the sewing; perhaps it is a gown for the infant. On her lap there appears to be a pacifier, or maybe a baby bottle.

The setting in this painting is luxurious; the woman sits on a needlepoint chair, and the rug at her feet is richly patterned with pastel flowers. Behind her is a black highboy cabinet, against which her delicate features are highlighted. The cabinet is trimmed with gold lacquer, and on the top decorative plates and a large vase are displayed. The walls are paneled and gilded, and painted with flowers. The fine cradle is of black lacquer with gold decoration. It has a painting of a winged cherub on the headboard, and elaborate rockers.

F. Sydney Muschamp is known for his romantic and idealized portraits of wealthy Victorians, and *The New Arrival* is typical of his style. It is a tender and loving salute to motherhood, and the needlework is only incidental. Nonetheless, a woman of this era was expected to be skillful with a needle.

F. Sydney Muschamp, 1829–1929

The New Arrival, c. 1880–1903

CIDER HOUSE GALLERY, SURREY, UK
ART RESOURCE

Emil Brack, 1860–1905
Musical Attentions, c. 1880–1900
BURLINGTON PAINTINGS, LONDON

Musical Attentions

The *double entendre* of the title of this work sparks our curiosity: does it refer to the woman paying attention to the man's music, or is he paying attention to—courting—her through his guitar-playing?

The eager young man perches on the arm of a small chair, earnestly playing the guitar. He is dressed in the stylish garb of the time, the breeches, the silk hose, the frock coat and ruffled jabot and cuffs hearken back to the Revolutionary-era United States. He even "makes a leg," as was fashionable at that time, turning his lower leg sideways so that others can admire his muscular calf.

The young woman remains intensely focused on her needlework. If a young woman sat quietly involved in her stitching, despite these distractions, she gave off all the indications that she would make a good wife: docile, submissive, industrious, accomplished, and unchallenging. This scene reveals a great deal about courtship at that time.

The woman is dressed elegantly in a pink satin "waist" (blouse), with elaborately trimmed lapels and collar. Part of her camisole is glimpsed at her bosom. Her skirt has pink and cream stripes, with small decorative elements and a ruffle at the hem. Her dainty feet rest on a cushion. Her blonde hair is piled high on her head, which indicates she is a woman rather than a girl. A half-smile flickers on her lips, no doubt offering encouragement to the young man, and she is blushing. She works on a lace-edged cloth, possibly a shawl or a small tablecloth.

The parlor in which they are seated is sumptuous: everywhere one looks there are signs of wealth and gentility. The wallpaper is a silk stripe; there is an Oriental carpet on the floor. A heavily embroidered rug covers the table between the couple, and the woman has a beautiful sewing table to her left, which is full of sewing paraphernalia and unfinished projects. A fine clock sits on the mantel; this was a time when clocks were a luxury. Gold-leafed sconces are hung on either side of the elegant mirror. Chinese vases flank the clock. Here and there one can see glimpses of richly embellished white and gold paneling. In the corner behind the young gentleman is a piece of furniture that is possibly a desk because the open panels are curtained, so this is not a place to display treasures. A small book, perhaps a Bible, is placed beside her, reflecting her literary pursuits and her virtuous character.

Lydia at Her Tapestry Frame

Lydia Cassatt was the sister of the renowned American painter Mary Cassatt (see pp. 72–73, 84–85, 88–89, 140–41). Neither sister married, and Lydia accompanied Mary to Paris so that Mary could pursue her painting career. Both sisters were artistic. Mary painted in the circle of the Impressionists, Lydia preferred to engage in the needlearts.

Lydia also served as a subject of numerous Cassatt paintings, appearing not only as a needleworker, but also in scenes in which she is shown drinking tea, posing with other women, attending the theatre, and reading the newspaper. These were all approved activities for genteel women of this era, and such paintings by Cassatt also advertise the well-educated status of her family.

In this painting, Lydia's head dominates the design, but it is balanced by a strong diagonal line from the left to the center of the painting. The features of Lydia's face are distinct, but her hands are not, thus emphasizing her identity, rather than her activity. Lydia is working at a needlework frame and, in spite of the title of the painting, she is most likely doing needlepoint. The fact that she is working on a fully stretched canvas indicates that this is an item meant to decorate the home, and would be valued for its artistic merit.

Lydia wears a comfortable day dress of warm pink and red tones, and sits on a chair of a similar color. In the background we see a heavy piece of furniture, possibly a piano or a large dining-room buffet. Lydia's face is bathed in a warm light; this is obviously a portrait, not a genre painting.

Eleven Mary Cassatt paintings feature Lydia as the subject, demonstrating the sisters' close relationship.

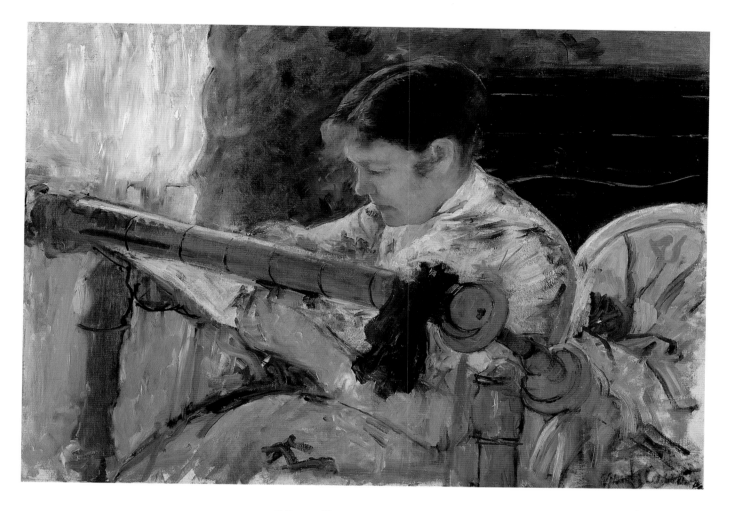

Mary Cassatt, 1844–1926
Lydia at Her Tapestry Frame, c. 1881
FLINT INSTITUTE OF ARTS, MI

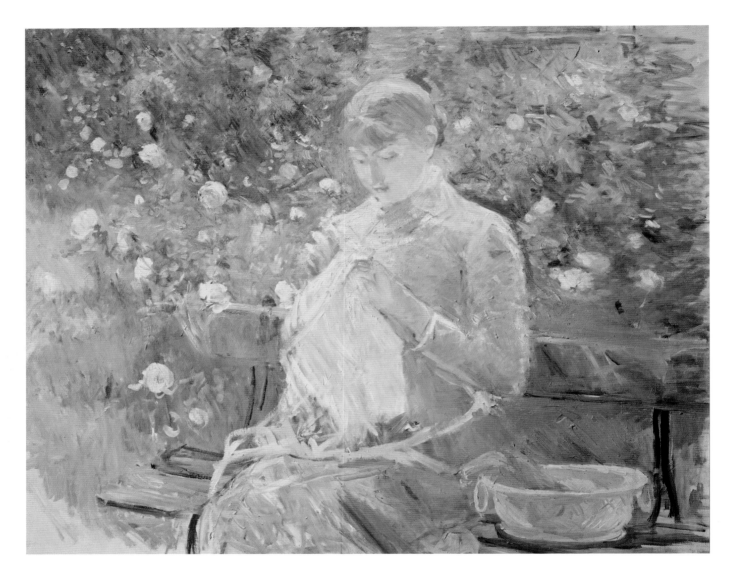

Berthe Morisot, 1841–1895
Pasie Sewing in the Garden at Bougival, 1881–82
(*Pasie cousant dans le jardin de Bougival*)

MUSÉE DES BEAUX ARTS, PAU, FRANCE

Pasie Sewing in the Garden at Bougival
(Pasie cousant dans le jardin de Bougival)

A young woman is seated on a blue bench; she is surrounded by pale pink and white roses, and is intent upon her sewing. This is one of numerous portraits of Pasie, the nanny of Julie Manet, who was the child of the Impressionist artist Berthe Morisot (see∞pp. 70–71, 106–107). In many of these works Pasie is depicted with her needlework. At least she was a convenient sitter, readily available to her mistress, and attractive.

In *Pasie cousant*, Pasie wears a lavender dress with white lace at the collar and cuffs. Her blonde hair is neatly arranged, and her eyes are cast down on her work. In spite of the elegant setting and occupation, Pasie is not the mistress of the house, but rather the nurse to the child. However, in this painting we see no evidence of Julie, and if we did not know otherwise, we could be forgiven for assuming that Pasie is a well-born young woman.

Pasie is very much the focal point of this painting, and dominates the center of the composition. Further inspection reveals the wall of a house in the background, and its leaded-glass window panes. A small path goes off to the left and a riot of roses surrounds Mlle Pasie and her sewing basket beside her on the blue bench.

It is difficult, if not impossible, to ascertain the nature of her sewing; it is possibly something as mundane as mending, but it could also be white-on-white embroidery, which was fashionable at the time.

Woman Embroidering on the Terrace

For a needleworker this is the perfect way to spend an afternoon. A young woman reclines in a relaxed posture and works on her needlepoint. She wears a long white gown with a ruffled trim along the front of the skirt. The sleeves of her dress end in a wide fluted cuff, and these are bordered with the same narrow ruffle found on the front of the gown. She wears a small, black, lacy shawl around her shoulders, but no hat. Her dark brown hair is curly, and held back behind her ears.

The embroiderer fills much of the scene, with background details giving us only small hints about her environment. A small portion of the house is visible to the right; it has Classical details, plus some rough stone elements, but it is difficult to determine much else. There are aging stone steps, and several pots of flowers, scattered about to add color to the setting. The foliage visible between the legs of the chair appears to be distant trees. The chair itself seems to be a folding type, with six legs, and perhaps a foot rest.

It is tempting to ponder on the woman's circumstances. She could merely be doing something she really enjoys, or she may be the young daughter of the house, sent away to work on her stitching. She could be a young mother snatching a few moments of peace with her needlework.

The needlewoman is working on a piece of canvaswork, something that would probably cover a chair or footstool. This is luxury needlework, not prosaic sewing or mending; this, together with the elegance of her clothing, would point to her having a comfortable station in life.

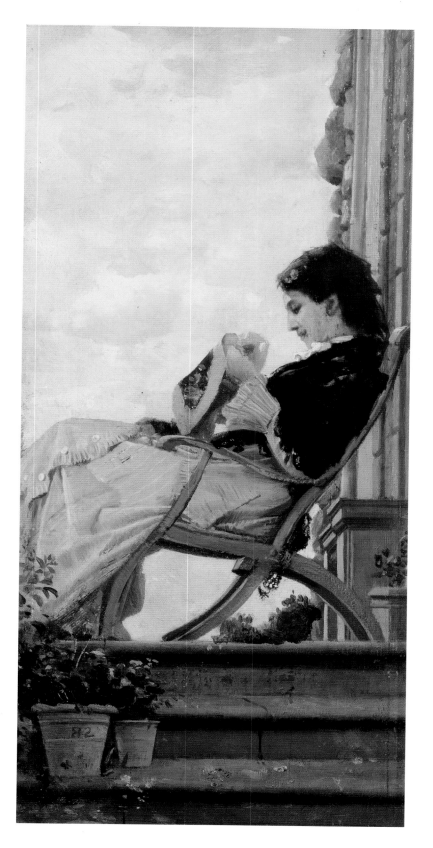

Christine Banti, 1824–1904
Woman Embroidering on the Terrace, 1882
GALLERIA NAZIONALE D'ARTE MODERNA, FLORENCE, ITALY

Marie-Thérèse Durand-Ruel Sewing

This dazzling portrait has as its subject the fourteen-year-old Marie-Thérèse, daughter of the well-known Impressionist art dealer Paul Durand-Ruel. Pierre-Auguste Renoir attracts the viewer's eye with the brilliant red-brimmed hat worn by Marie-Thérèse, which elevates this painting from the pedestrian to the exceptional in ingenue portraiture. Marie-Thérèse was not known to be a great beauty by the standards of the day, yet in this painting she holds a fascination for the modern viewer, primarily due to Renoir's bold use of color.

Marie-Thérèse appears intent on her sewing. She seems relaxed and comfortable with her needlework, but resolutely engaged in the project. Sigmund Freud later hypothesized that the amount of time devoted to needlework by young women might lead to daydreaming and ultimately to hysteria, but Marie-Thérèse appears enthusiastic about her endeavors and seems far from any such condition. Her head is tipped forward in the classic embroiderer's pose, and she holds the sewing rather close, so one might infer that she is near-sighted.

Marie-Thérèse wears a brilliant blue dress with lace at the cuffs and neckline, and her abundant brown hair cascades over her shoulders and seems to flow below her waist and out of the picture. It is confined at the nape of her neck with a dark red ribbon. Unlike those of the young women in many Impressionist paintings, Marie-Thérèse's features are well defined, against a riotous background of flowers and greenery; the setting suggests an intimate garden. This painting does not seem to imply incipient sexuality, most likely because it was for Renoir's friend and mentor. Nevertheless, it is said that Durand-Ruel was not fond of this painting.

As a noted art dealer, Durand-Ruel patronized the Impressionists when no one else would. He is considered to have been instrumental in their ultimate success, to a great extent because he took their paintings to New York and exhibited them at a time when the French art establishment showed no interest in these revolutionary painters.

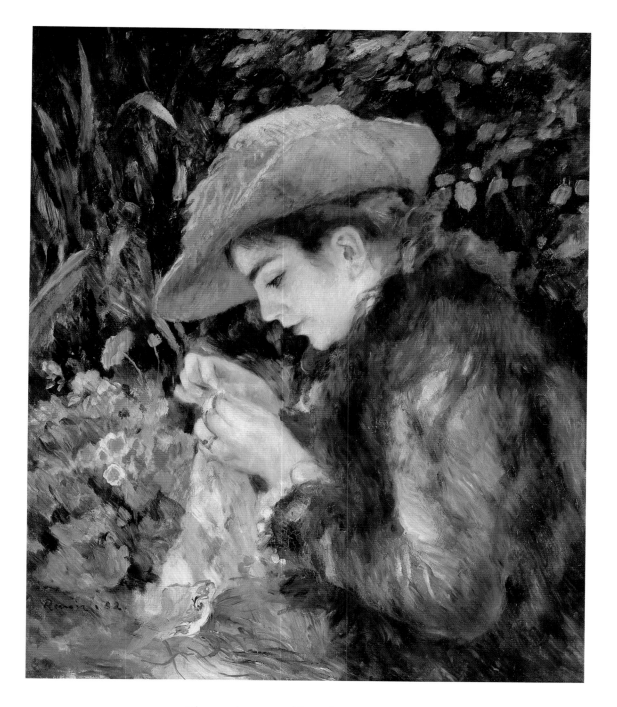

Pierre-Auguste Renoir, 1841–1919
Marie-Thérèse Durand-Ruel Sewing, 1882
STERLING AND FRANCINE CLARK ART INSTITUTE, WILLIAMSTOWN, MA

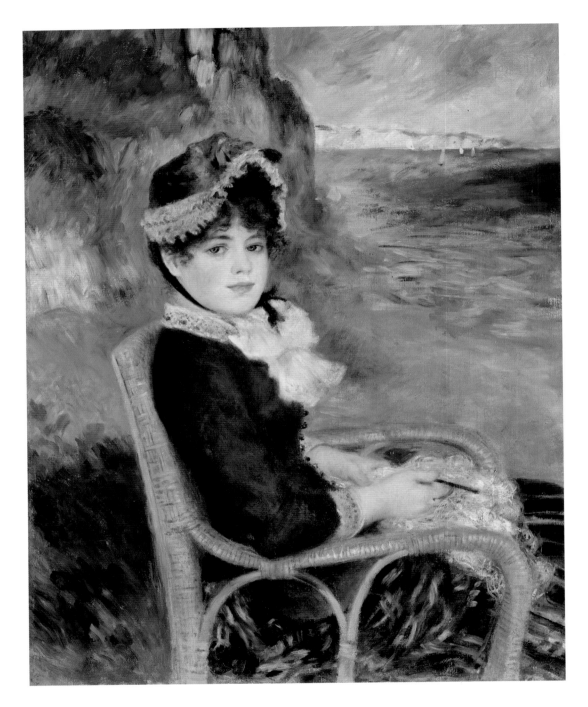

Pierre-Auguste Renoir, 1841–1919
By the Seashore, 1883
THE METROPOLITAN MUSEUM OF ART, NEW YORK

By the Seashore

In this painting, Pierre-Auguste Renoir has depicted a beautiful, stylishly dressed young woman enjoying a quiet moment on the shores of the Mediterranean. In her hands she holds what appears to be lacy crocheting, and indeed closer inspection reveals that she is holding a crochet hook.

Some believe the woman to be Aline, the wife of Renoir, although the hair seems darker than that of Aline, who appears red-headed in other paintings. She regards the artist, and us, with a steady gaze, looking up from her work.

In the background, the sea is interpreted with a loose Impressionistic technique, but the woman is painted clearly. She wears a gown of the same deep blue as the sea, and her modish hat repeats this color. In the style of the late nineteenth century, the model wears lace at the collar and cuffs of her dress, and on the brim of her hat.

The yellow chair is rattan; the colour of this, combined with the blue of the dress and the sea, evokes the South of France. We know that the Renoirs visited the Côte d'Azur during this period.

Children's Afternoon at Wargemont

Children's Afternoon at Wargemont is a commissioned portrait of the daughters of Paul Bérard, a longtime patron and friend of the artist Pierre-Auguste Renoir. In the painting all three girls typify the behavior of the well-bred, upper-middle-class young French girls of the period, although written evidence reveals that they were really quite tomboyish.

Wargemont was the summer home of the Bérard family, and Renoir spent many weeks there painting the family and enjoying country life. The interior features the comfortable and elegant furnishings of a French country home. The simple blue-striped fabric of the love-seat complements the heavily patterned rug on the table and the crewel-embroidered drapery.

But it is the daughters who dominate the painting. Their activities seem to represent various stages of childhood, with the youngest sister, Lucie, holding her doll, and appearing to seek the attention of her oldest sister. The middle sister, Marguerite, has graduated to a more learned activity: she concentrates on reading a book. The oldest sister, Marthe, is on the verge of womanhood, and she busies herself with that absolute requirement of every young nineteenth-century woman: needlework. The placement of the doll on her lap by her sister is perhaps meant to prefigure the responsibilities of marriage and motherhood.

The colors in the background are complementary, with the warm orange tones on the right half of the painting set off by the cool blues on the left; small areas of the complementary colors appearing in the opposite half tie the composition together. Against this background, the figures and faces of the girls stand out, especially those of the oldest sister.

One can find dozens of paintings of sisters, depicting one girl reading and another embroidering, produced in France during the Impressionist era. This was an indication that the young women were well educated for the time, being accomplished with their needlework and able to read.

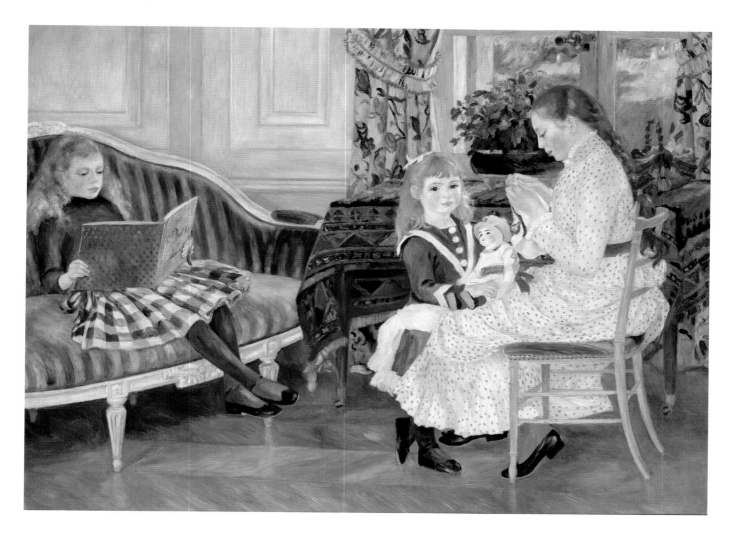

Pierre-Auguste Renoir, 1841–1919
Children's Afternoon at Wargemont, 1884
NATIONALGALERIE, BERLIN

The Artist's Daughter, Julie, with her Nanny
(La Leçon de couture)

Berthe Morisot is the "other woman Impressionist," lesser known today in America, but the equal of Mary Cassatt alongside their male contemporaries in late nineteenth-century Paris. Berthe and her sister Edma both developed an interest in painting as young girls, and their parents were able to provide their daughters with professional painting instruction—-and many visits to the Louvre. This was a time when many young women dabbled in painting; it was considered a genteel accomplishment for the haute-bourgeoisie female. Berthe, however, was exceptional in wishing to pursue art as a profession.

Morisot's work is characterized by the typical Impressionist use of bright colors, which she applied using a delicate, feathery technique.

Berthe Morisot was acquainted socially with Edouard Manet, whom she met in 1868. She married Edouard Manet's brother Eugène in 1874, and they had one daughter, Julie. Edouard Manet is considered the father of the Impressionist movement, and through him Morisot met the other revolutionary painters of that circle. Indeed, Manet used her as his model for several paintings. Morisot and Manet were very like-minded artistically, and they influenced each other. It is believed that there may have been a romance between them, although it may have been only an infatuation on her part.

Julie and her nanny, Pasie were frequent subjects of Morisot's paintings. In *The Artist's Daughter*, Morisot portrays Julie Manet as a child of perhaps seven or eight, who is being taught to sew by Pasie. Pasie wears a dark blue dress with a high collar, and her dark blonde hair is arranged simply. The child's hair color echoes that of the nanny. Julie's dress is a dark blue-green. Both figures gaze intently at the embroidery and their facial features are fairly distinct. The embroidery is in the center of the painting, and a strong vertical line in the background directs our eyes to it. The hands of the models are barely discernible; it is their youthful faces on which we concentrate.

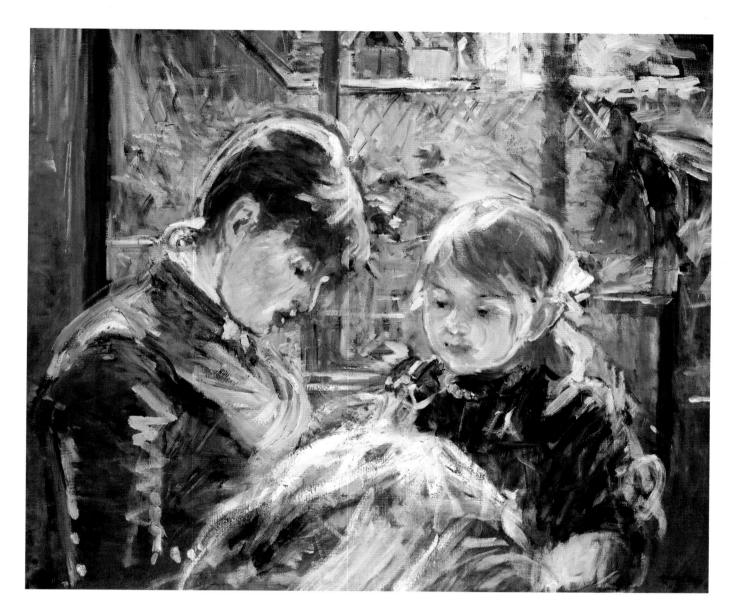

Berthe Morisot, 1841–1895
The Artist's Daughter, Julie, with her Nanny, 1885
(*La Leçon de couture*)
MINNEAPOLIS INSTITUTE OF ARTS

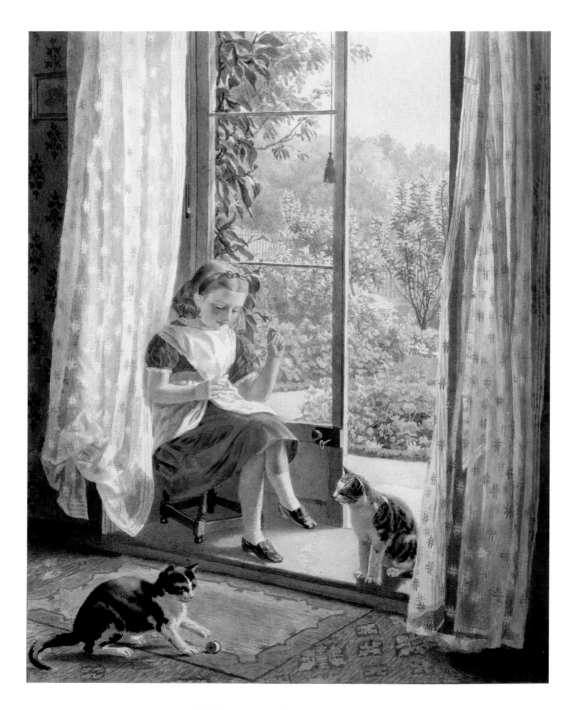

Helena Maguire, 1860–1909
A Summer Afternoon, c. 1885–1900
BURLINGTON PAINTINGS, LONDON

A Summer Afternoon

A Summer Afternoon by the British artist Helena Maguire shows a young girl sitting by
an open French door, absorbed in her needlework. With her blue gown, Maguire's subject
bears a strong resemblance to Alice-in-Wonderland. Her hair is blonde like Alice's,
held back by a blue headband, and she wears the shoes of that era. She is clean and
meticulously presented, with leisure time to learn the expected skills of an adult woman.

One may surmise that this is a child of privilege; a patterned rug covers the floor, lace
curtains float in the gentle breeze at the window, and outside we can see a lush, opulent
garden, full of flowers in full bloom, blossoming trees, and climbing vines. The full bloom
outside declares that it is the height of summer, as does the open door. Adding interest
and more life to the scene are two cats, one at the stitcher's feet, the other batting at a
spool of thread. *A Summer Afternoon* is a scene of an idyllic childhood—and thus of
great appeal.

Helena Maguire was an artist of Victorian and Edwardian England, working as a painter
and a book illustrator. She is well known for sentimental paintings of children and
especially of cats.

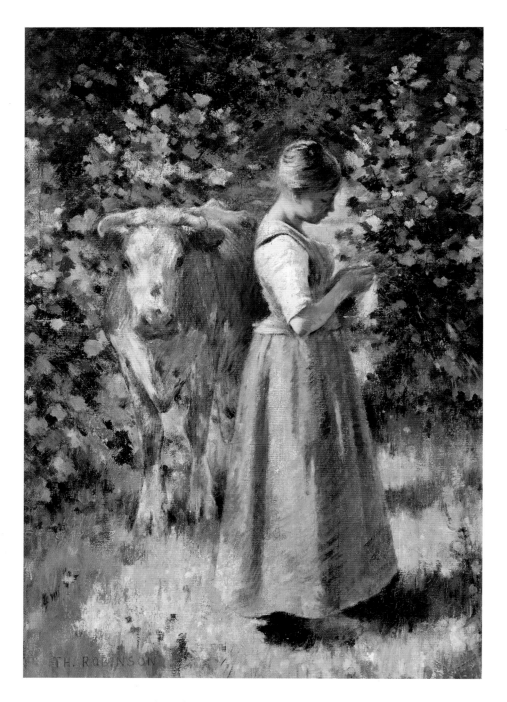

Theodore Robinson, 1852–1896
The Milkmaid, 1888
(*La Vachère*)

The Milkmaid
(La Vachère)

Theodore Robinson was among the first American artists to study with the Impressionist painter Claude Monet at Monet's house at Giverny, about forty miles from Paris. This was the beginning of the notable American art colony there.[1] Unlike later acolytes of Monet, Robinson actually developed a relationship with the master, and some of what we know about Monet's later years comes from Robinson's writings. On his first sojourn in France, Robinson had also lived in the French town of Barbizon, where Jean-Françoise Millet and Théodore Rousseau lived and produced landscape paintings. Their influence on Robinson can be seen in his depiction of pastoral scenes and the somber color palette of some of his paintings.

Robinson has painted his favorite model, the enigmatic Marie, as a milkmaid. She is pictured in a lush field and is intent on her needlework, while her cow stands patiently behind her. The darkness of the green field and trees seems to refer back to Robinson's work in Barbizon; however, the light flooding the area where Marie stands shows the influence of Monet, as does the treatment of the leaves and wild flowers.

Robinson painted Marie engaged in a number of refined pursuits, such as reading, needlework, and music.[2] We do not know whether Marie was a bourgeois or working-class woman, but Robinson portrays her lovingly in many paintings. Here she is dressed as a peasant girl engaged in an occupation that consumes little of her attention or effort, thereby enabling her to occupy herself with her sewing. She appears to be hemming a handkerchief or napkin; such small items would have been easy to carry and thus would be appropriate for outdoor work.

There is another much smaller painting by Robinson that is very similar to this one, called *In the Grove*, except that the cow is not present.

Many other painters have portrayed young women engaged in their needlework out of doors, and many of them are standing, as Marie is here. It must have been difficult to stitch in such a pose.

1 *American Impressionists Abroad and at Home: Paintings from the Collection of the Metropolitan Museum of Art*, exhib. cat. by Barbara Weinberg and Susan G. Larkin, San Diego, Delaware, Nashville, Orlando and New York 2001–2002.
2 *In Monet's Light: Theodore Robinson at Giverny*, exhib. cat. by Sona Johnston, Baltimore Museum of Art 2004, p. 145.

In Love

In this courtship scene by the English romantic artist Marcus Stone, a demure young maiden focuses on her needlework, while a young gentleman endeavors to attract her attention. His full attention is fixed on the object of his affections, while she, on the other hand, appears engrossed in her sewing, a suitably modest response from a well-bred woman of her era.

This painting abounds in symbols. A sculpture of Cupid is placed between the pair, with his arrow aimed directly at the man. Apples, the symbol of Eve's downfall, are scattered about on the table, and one has fallen to the ground near him, suggesting that the lady may have already succumbed to temptation. She is dressed in virginal white, in an attractive summer gown, but already she has taken off her hat, perhaps signaling her interest, and her cheeks are flushed. She has placed his offering of flowers to one side, but it appears that she has accepted them.

"Eyes lowered, head bent, the embroiderer's pose signifies subjugation, submission, and modesty, yet her silence also suggests self-containment, a kind of autonomy. The silent embroiderer has, however, become implicated in a stereotype of femininity in which the self-containment of the woman sewing is represented as seductiveness."[1]

Social mores were very different in the nineteenth century; women were brought up to be quiet and demure, not too learned but accomplished in the needlearts. Delicate handwork became the symbol of all these traits—docility, domesticity, diligence, demureness—in the desirable young woman, and represented her most alluring quality.

1 Rozsika Parker, *The Subversive Stitch*, London (The Women's Press) 1984, p. 10.

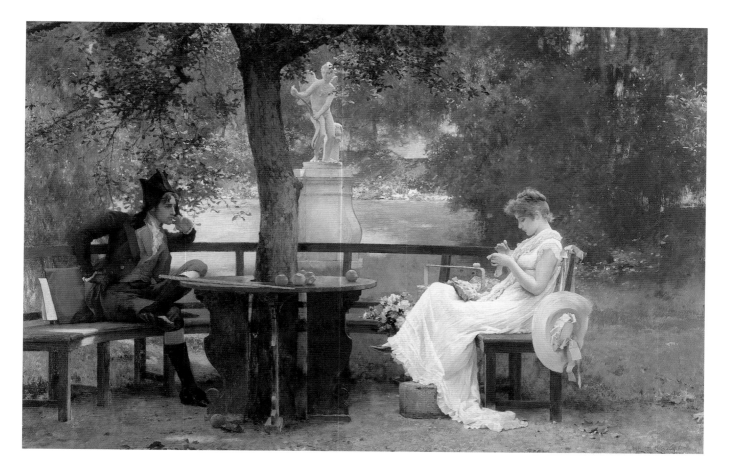

Marcus Stone, 1840–1921
In Love, 1888
NOTTINGHAM CASTLE GALLERY, UK

The Lacemaker

A red-haired woman sits in the courtyard of what is probably a farmhouse. Although she is working with the most delicate of materials, in the most exacting type of needlework, demanding infinite cleanliness, she is, nevertheless, outdoors, with chickens scratching nearby. The large door behind her must be the entrance to either a barn or a carriage house. At the left is a lean-to built of small branches, which is probably a shelter for animals, or a place to store equipment. The legs of a manger sit there, too. The picturesque cream-colored stucco and the red-tiled roofs are characteristic of farmhouses in the South of France.

The lacemaker herself has some shade over her, as she prepares to start her work. Her paper pattern is unfurled in her lap; a rolled-up piece of fabric serves as her pillow, and

she holds scissors and thread in her hand. Her clothing has almost a schoolmarmish look to it, with its striped blouse and long gray skirt, and the hair piled on top of her head adds to the effect. She sits on a straight chair with her feet on the rungs of another, which also serves to hold her supplies.

The chickens are a charming secondary focal point in this design. One wonders, though, why the woman would take this delicate project outside. It may be for the light, because farmhouses of that period were dark and smoky. In artworks depicting stitchers the needlewomen are often sitting at a window; perhaps this lacemaker decided to take advantage of the pleasant weather and better light in the courtyard.

It is worth noting that the artist's last name is Tapissier, which means "tapestry maker." Somewhere in his family history another craftsman created beautiful artworks, and his skills must have been handed down to this painter.

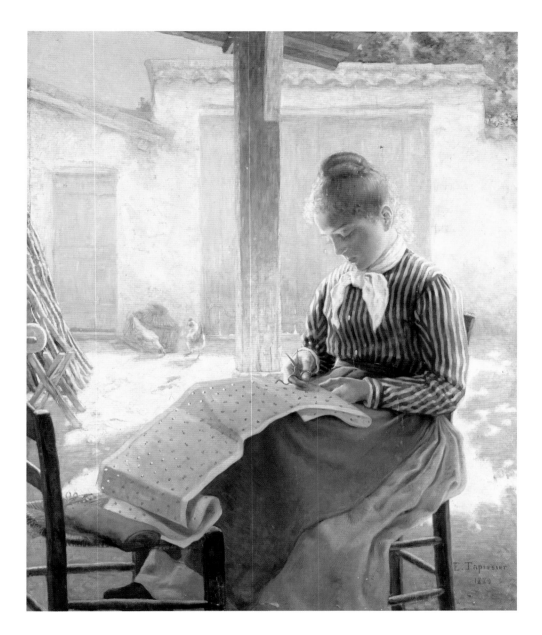

Edmond Tapissier, 1861–1943
The Lacemaker, 1889
CHÂTEAU-MUSÉE NEMOURS, ÎLE-DE-FRANCE

Night (after Millet)

Night (after Millet) is based on a print by Millet from the series *Les Quatre Heures de la Journée* (The four times of day). The four scenes represent typical activities in a day of the peasant class. Vincent van Gogh was inspired by Millet's sympathetic depictions of the life and work of the peasants, an approach that was revolutionary for its time. Van Gogh himself felt a great identification with the poor, and was compassionate toward their plight. He was suspicious of the ongoing Industrial Revolution and the way the new inventions exploited the labor of the poor.

In *Night (after Millet)* we see the loose brushstrokes for which Van Gogh would become so well known, but here he uses a somber palette, appropriate to the subject-matter. The setting is the interior of a peasant's cottage, probably a one-room building, and it is lit by a single lantern, with perhaps a small amount of light coming from the nearby fireplace.

A couple is pictured sitting close to the light, and both are engaged in quiet work. One may surmise that they have spent an arduous day working in the fields and caring for their family; nevertheless, they do not waste the evening hours, but remain productive, albeit with more restful work. The woman is pictured in profile, seated on a straight chair, and dressed in simple clothing. She holds in her hand some needlework, which appears to be embroidery, for the cloth is stretched in a hoop. The item seems to be a garment of some sort; perhaps it is a special shirt or blouse for church or festivals.

The man's hands are occupied, too; he is weaving a basket, and he sits on a stool, hunched over his task. Next to him is another basket, containing either small logs for the fire, or more materials for the basketmaking.

One almost misses the child sleeping in the background; he is oblivious to the light of the lantern and to his parents' travails.

To the left is the fireplace, seemingly large, and on the hearth sits a small cat. His presence, and the warmth of the light, are all that relieve the bleakness of the scene.

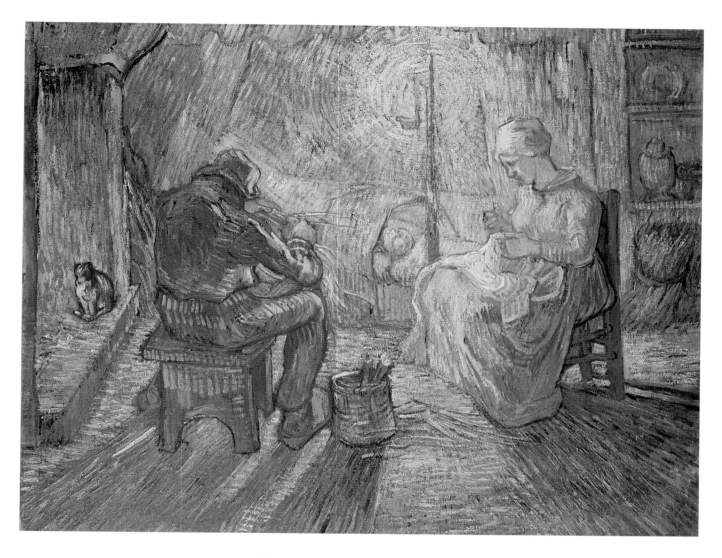

Vincent van Gogh, 1853–1890
Night (after Millet), 1889
VAN GOGH MUSEUM, AMSTERDAM

Family in an Orchard

This beautiful painting epitomizes every stitcher's dream: to spend a sunny afternoon out-of-doors, shaded by trees, with nothing to do but enjoy one's stitching, in the company of friends who are similarly engaged. In nineteenth-century Europe the bourgeois woman was blessed with servants and she was only responsible for overseeing them; otherwise she had much free time to fill with such pleasant activities as visiting friends, and her needlework. In spite of the fact that she was excused from the more difficult household tasks, she was nevertheless expected to be industrious, not idle. Often her time was devoted to her embroidery, that universally desired accomplishment.

Théo van Rysselberghe has painted an idyllic scene, with five women comfortably dressed in the fashion of the era, complete with long full skirts and wide-brimmed hats to ward off the sun's rays.

Four of the women are seated under a spreading tree, but only one seems to have a comfortable chair; some of the others appear quite formally seated on hard chairs. Small tables hold the baskets of yarns, and some flowers add a note of color. At least two of the women seem intent on their stitching, their heads bowed and their hands brought up in the characteristic pose of the needlewoman. A third woman does not look down, but appears to be talking, her hat casually held behind her, which gives us a partial view of her face.

Behind the group is a fifth woman, her red sash fluttering in the breeze as she walks along purposefully. It does not seem that she is about to join the other women under the tree, although a chair is vacant. She holds no sewing, and no basket sits by the empty chair; perhaps she eschewed needlework, which could have made her unconventional and regarded as a "difficult woman" at the time.

In the distance one can spot some other people, apparently picking fruit from the trees. There is a hint of a fine house behind them. The title suggests that these women may be the family of Van Rysselberghe; sometimes several generations occupied the same home, including single sisters and maiden aunts.

Van Rysselberghe was a Belgian Neo-Impressionist who experimented with the pointillist technique adopted by Georges Seurat and Paul Signac, which he employs in this painting. He uses small dots of pure color placed close together to achieve a luminous effect when seen from an appropriate distance.

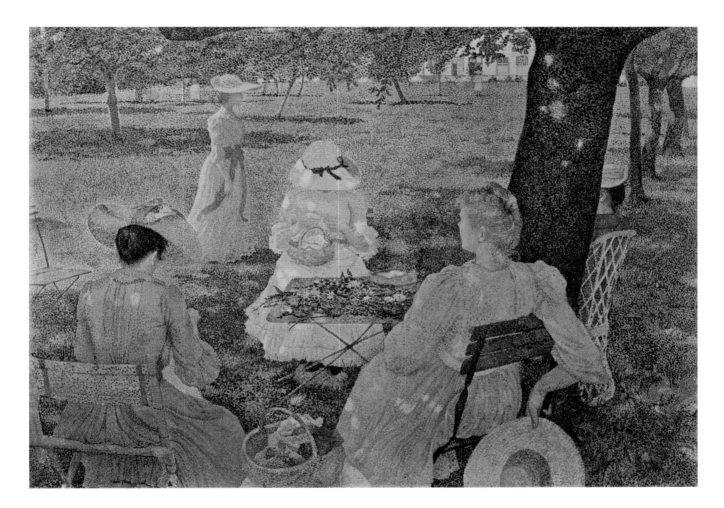

Théo van Rysselberghe, 1862–1926
Family in an Orchard, 1890
RIJKSMUSEUM KROELLER-MUELLER, OTTERLO, THE NETHERLANDS

Francisco Oller y Cestero, 1833–1917
The Student, c. 1890–1900
(*L'Etudiant*)
MUSÉE D'ORSAY, PARIS

The Student
(L'Etudiant)

In this scene, the Puerto Rican artist Francisco Oller y Cestero has captured a moment in the life of a young woman apparently under the tutelage of her companion. The title suggests that some kind of instruction is in progress, but the woman seems engrossed in her sewing, while the man appears intent on his reading. There seems to be little contact between them.

The woman sits hunched over a large piece of dark cloth. Her feet are propped on the rungs of the chair in front of her, in a casual, informal posture. This serves to elevate the sewing to a comfortable working level. We see little of the woman's face; her dress seems fashionable with its blue bow and ruffled collar, but she is otherwise unadorned.

The gentleman wears a suit, and sports a long beard. He is absorbed in his book, and may be reading aloud to her, giving her a literature lesson, or teaching her a foreign language. Were it not for the title, one might assume that this is a couple, comfortable in being silent with one another and each pursuing his or her activity. It also may be possible that he is the student, busy preparing for an examination.

This painting does tell us about domestic interior design of the late nineteenth century, and that a much busier aesthetic was favored than is popular today. The wallpaper is a detailed print, the drapery is also figured, and the wall is covered with many small works of art, a small shelf, and a device that is probably a servant's bell but may be an early telephone. The mirror reveals some intriguing detail. There appears to be a door leading from the room, but it is really a cabinet with a second mirror that reflects the room we see, showing only the items to the far left of the painting. We can also see a curtain in the mirror, which may conceal a bed hidden away when not in use, in what is possibly the artist's studio.

This enigmatic painting asks more questions than it answers; it is intriguing in its detail and strange tableau.

Sunlight in the Blue Room
(Helga Ancher Crocheting in her
Grandmother's Room)

The Danish Impressionist Anna Ancher has created vivid contrasts of blue and yellow-orange in this painting. She has depicted her eight-year-old daughter, Helga, perched on a chair at the edge of a blue room. Her back is turned toward us, but her luminous blonde hair attracts the eye immediately.

Blue dominates this painting: the wall in the upper left quadrant is of an intense blue, and the color is repeated in the seats of the chairs, in some of the stripes on the rug, and in the girl's pinafore. The blue is complemented by the yellow-orange of the drapery, the stripes in the rug, and in the furniture visible at the left edge. These elements serve to emphasize the child's hair, and our eye is drawn repeatedly to her as the focus of the painting.

A painting placed high on the blue wall appears to be a portrait of the Virgin. Another subtle element, which brightens the painting and adds so much vitality to it, is the shadow of a spindly bush growing outside the room, which the sun has projected on to the wall.

Helga is said to be crocheting, and indeed it is easy to spot the ball of yarn lying on the blue stripe of the rug; it is connected to her work with a web-like strand of yarn. There are other paintings of this girl as she matures, and in most of them she is doing some kind of needlework. It is only when she is a teenager that she, too, begins to draw and paint.

The work of the Skagen painters seems to feature many needleworkers; it may be that members of the artistic community who did not paint expressed themselves creatively with their needlework.

Anna Ancher, 1859–1935

Sunlight in the Blue Room (Helga Ancher Crocheting in her Grandmother's Room), 1891

SKAGENS MUSEUM, DENMARK

J. Bond Francisco, 1863–1931
The Sick Child, 1893

The Sick Child

In this interior scene, the artist has painted an anxious woman sitting at the bedside of an ailing child. Her posture suggests tension and worry, as she leans forward to look at the boy. The child sleeps quietly, clutching a toy clown in his hand, hanging on to it by only one leg, perhaps symbolizing the tenuousness of his grasp on life. To the left, on a small bedside table, are the medications and remedies left by the doctor.

It is significant that the woman, possibly the boy's mother or another relative, is knitting. There are many paintings that portray a mother near a sleeping child, and often the woman is occupied with her needlework. Even today, needlework is considered an appropriate way to use "waiting" time in a productive manner.

Today stitchers often declare that "needlework is my therapy." Whether she is recovering from an illness, coping with a divorce, or a difficult child, or the care of an aging relative, time and again the needlewoman asserts that she could not have coped without the comfort of her stitching. We may speculate that the repetitive nature of stitching is almost like meditation, but there is no doubt that, for the person who enjoys needlework, the very act has a calming and soothing effect.

In the early part of the twentieth century *The Sick Child* was a well-known painting, as it hung on the walls of numerous doctors' offices throughout the United States.

Clotilde

Clotilde, or *The Knitter* as it is sometimes called, is an unpretentious painting that affirms the affection that artists and their patrons have for the subject of the needlewoman. In this picture, Louis Paul Dessar has depicted an ordinary woman standing at a curtained window, earnestly intent on her knitting.

Everything about this painting is homespun and humble. The walls are plain and whitewashed; the windowsill is broader than usual, supported by legs, and wide enough to accommodate some cooling pies, a child doing homework or, in this case, some pots of geraniums. Plain, sheer curtains flutter at the window, diffusing the sun but allowing the geraniums to bask in its light. Only the frame is colorful, a vivid turquoise that complements the orange of the flowers, the dark orange of the knitting, and the pale pink-orange of the woman's skirt.

The woman is simply dressed, with an apron indicating that she could be a domestic in this household. There is nothing glamorous about her in either dress, hairstyle, or demeanor, and her feet seem out of proportion to the rest of her.

It appears that she is knitting either a sock or a mitten, for her hand position suggests that she is holding four needles rather than the usual two. This American artist has offered a testimony to the dutifulness and diligence expected of women of this era.

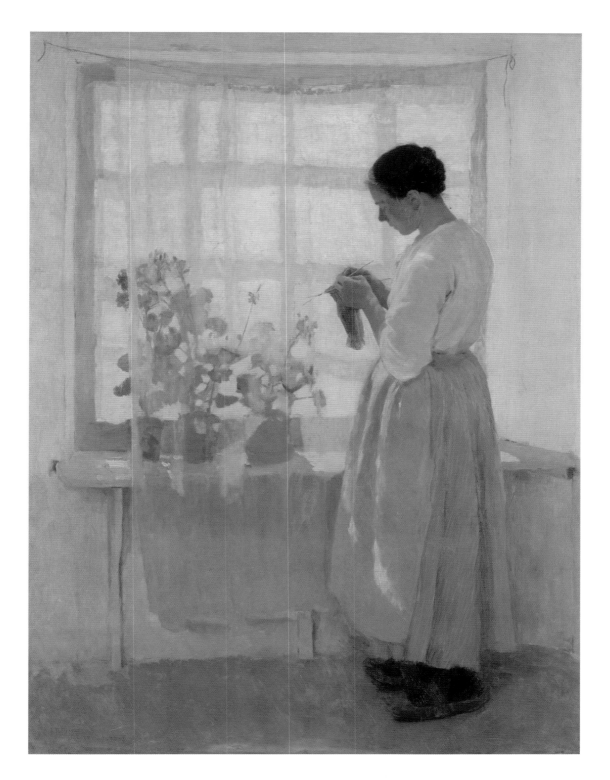

Louis Paul Dessar, 1867–1952

Clotilde, 1893

MUSÉE NATIONALE DE LA COOPÉRATION FRANCO-AMÉRICAINE, BLÉRANCOURT, FRANCE

A Sunday Afternoon

This is a most unusual painting of a stitcher, for the needlewoman is portrayed walking along, rather than in the usual sewing posture of sitting or, very occasionally, standing. But in this painting by Leopald Graf von Kalckreuth, a soberly dressed young woman strolls along with a man, most likely a suitor. Two-thirds of the painting is greenery: weeds, tall grasses, and wild flowers. Some of the grass is shoulder height, creating a wall of vegetation that dominates this composition. We can pick out the seed pods of the grasses against the pale-blue sky; they sway gently in a light breeze. One small element of interest interrupts the ragged horizon of the greenery: the steeple of a church in the nearby village, which may suggest the couple's relationship is sanctioned by God.

Lower down in the foliage are poppies, that ubiquitous flower of the European countryside: they tell us it is late spring. Some white flowers lie low along the trampled pathway, and dandelions are sprinkled along the way; here and there are some purple flowers, too.

It is the couple that attracts our attention, however. She is probably a woman of modest income, wearing her best dress for church, the title of the painting indicating that it is Sunday. Her dress is black, with only the tiniest hint of white at the neckline, and a small bustle at the back. Her hair is neatly gathered into a chignon, and she wastes not a minute of her leisure time, but knits a sock as she enjoys a walk. The man also wears black, but is without his jacket, thus revealing his shirtsleeves. The sleeves are the most prominent part of the scene, contrasting with the black of his clothing and the green of the vegetation. His cap appears to be part of a uniform but, since it is Sunday, we can only infer that this is the headwear of an ordinary man. Both have their eyes cast down, as if in serious conversation.

The artist was known for painting mostly realistic scenes, but did study with the Impressionists for some time. This painting shows elements of both painting styles.

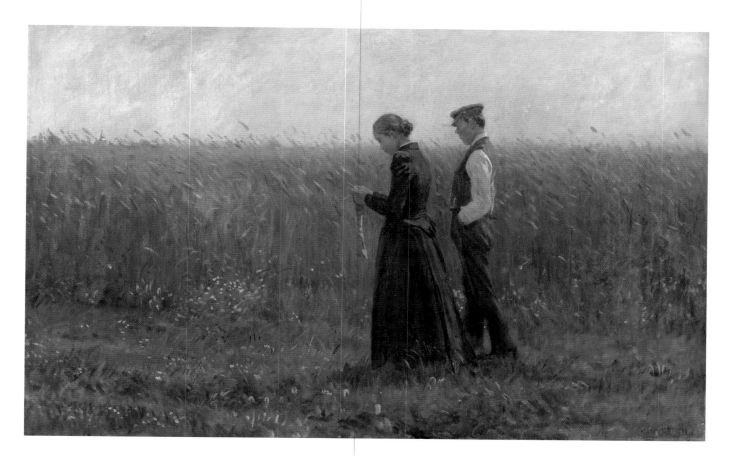

Leopold Graf von Kalckreuth, 1855–1928
A Sunday Afternoon, 1893
HAMBURGER KUNSTHALLE, HAMBURG, GERMANY

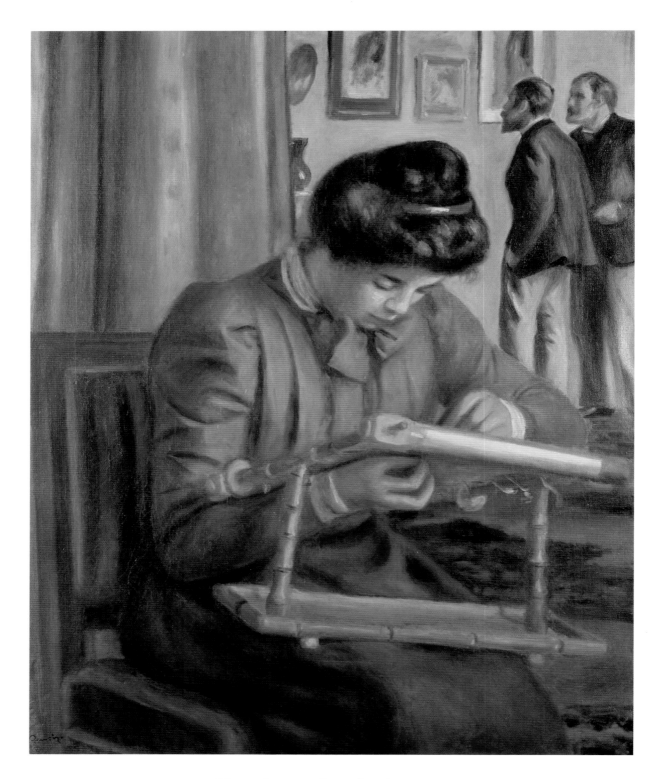

Pierre Auguste Renoir, 1841–1919
Mademoiselle Christine Lerolle Embroidering, 1896–97

COLUMBUS MUSEUM OF ART, OHIO

Mademoiselle Christine Lerolle Embroidering

Mademoiselle Christine Lerolle was the daughter of Henri Lerolle, an avid collector of Renoir's work, as well as that of the other Impressionists. Mlle Lerolle is painted in a brilliant red dress, typical of those worn by upper-class young women of her day. No doubt she has chosen this color to compliment her dark hair, which is further embellished with a decorative clip.

The woman is bent over her needlework and, although one cannot see exactly what she is working on, it can be surmised that it is needlepoint, perhaps Berlin work, which was very popular in that era. Her canvas is stretched tightly on the frame, and she holds her hands in the prescribed manner, with her right hand beneath the stitching, and her left above. The frame is furniture quality, seemingly of bamboo, and the extra threads used to further tighten the canvas are clearly visible.

The entire painting is suffused with warm hues. Renoir has even reflected the red of Christine's dress on to her cheeks and hair. Only the green stripes of the elegant chair on which she sits offer a color contrast. Mlle Lerolle is depicted in an elegant bourgeois interior, enlivened by such accents as the patterned Oriental rug, the Japanese vase in the background, and the silk drapery behind her.

As a secondary focal point Renoir has included his patron, M. Lerolle, and a man who is believed to be a contemporary Belgian sculptor. Both gentlemen are examining several paintings on the wall, believed to be by Renoir and Claude Monet.

Mlle Lerolle has been painted at least two other times by Renoir, once at the piano with her sister Yvonne, and again in an individual portrait. In the piano painting, which is much better known than this one, she is also wearing a red gown.

Since Mlle Lerolle has been painted both at the piano and embroidering, it is likely that she was an accomplished young woman of her day, for it was typical of upper-class families to be proud of their daughters' skills in the needlearts and music.

Christine Lerolle married Louis Rouart, a member of a prominent family of French art patrons. Her sister Yvonne married Louis's brother, Eugène. A third Rouart brother, Ernest, married Julie Manet, who was the daughter of Impressionist Berthe Morisot and Eugène Manet, the brother of the father of Impressionism, Edouard Manet. In the bourgeois society of Paris the lives of the artists, the dealers, and the patrons were intimately connected.

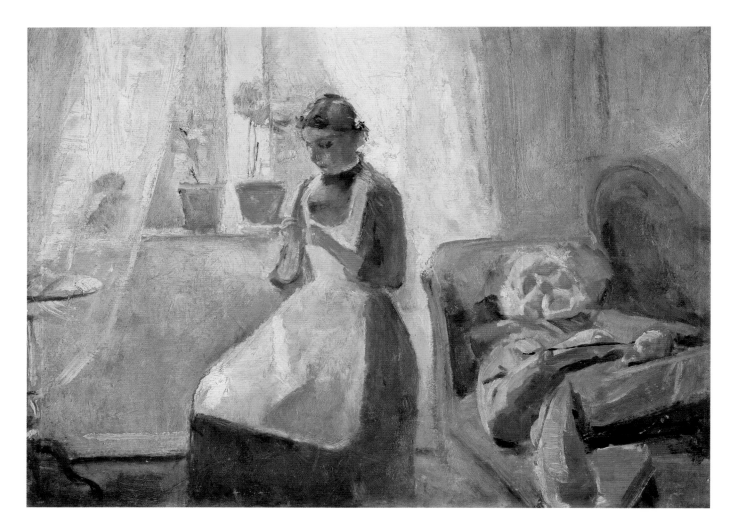

Edvard Munch, 1863–1944
The Siesta, 1897
MUNCH MUSEUM, OSLO

The Siesta

Edvard Munch has painted a quiet domestic scene in which the woman relaxes but still remains productive with her needlework, while the man, who may be her father or her husband, is sound asleep on the sofa.

This painting, with its sunny interior and pleasant domestic scene, allows us to peer into life in turn-of-the-century Norway. Lace curtains flutter at the window and flower pots decorate the sill. A small round table is placed at the edge of the painting, no doubt holding the woman's stitching tools. She is dressed simply in a gray dress with a white apron. The woman's hands are in the correct position for either fine sewing or crocheting.

The man looks weary in his repose, reflecting a life of hard work. He clutches something in his hand, even though seemingly asleep. The green of the sofa complements the red-orange of his clothing.

This painting is quite unconventional for Munch, who is best known for his painting *The Scream* (1893). *The Siesta* is painted in an impressionistic style, which he learned while studying in France. Here he uses a light touch with fleeting brushstrokes, giving no indication of his later move into Expressionism and dark themes. Even though much of his later œuvre is concerned with pathos and depression, Munch has nevertheless portrayed here the popular Impressionist scene of the needlewoman.

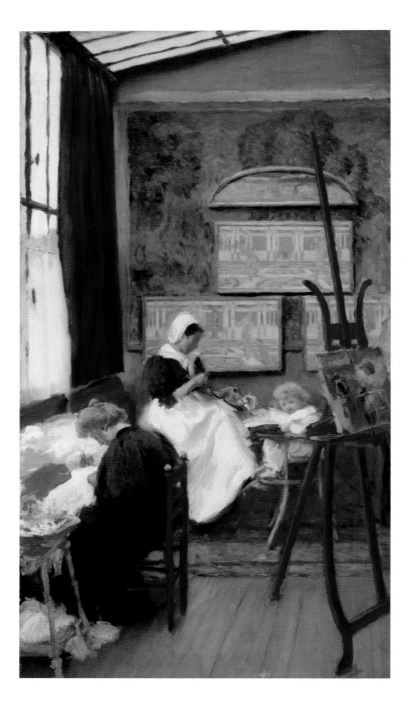

Mary Fairchild MacMonnies, 1858–1946
In the Nursery (Giverny Studio), 1897–98
DANIEL J. TERRA COLLECTION, THE ART INSTITUTE OF CHICAGO

In the Nursery (Giverny Studio)

Mary Fairchild was an artist living in Giverny, one of the many followers of Claude Monet. While there she met and married fellow American Frederick MacMonnies (1863–1937), a renowned sculptor of the time, and the two lived in France together, in an old priory jokingly known as the MacMonastery.

Like many female artists of her time, MacMonnies often painted indoors, with women and children as the subjects, as women were somewhat constrained from spending much time in public. This was less true in Giverny, which was a remote and protected environment.

The nursery in this painting also served as Mary MacMonnies's studio. To the right we see an easel, on which is displayed a painting in progress, known as *C'est la tête à bébé*. This is a portrait of the MacMonnies's youngest child, Berthe, whom we also see in the nursery painting, seated in her high chair. Berthe has a book to look at, but she turns toward the viewer.

In front of Berthe sits a maid, who appears to be sewing, although one cannot be sure. On the left side of the painting another woman, probably Mary MacMonnies herself, sits busy with her sewing. Next to her is a typical sewing basket of the era, with fabrics tumbling from it on to the floor. This room would have been an excellent space for both sewing and painting, as a skylight is visible, and a tall window also lights the scene.

On the back wall are MacMonnies's copies of paintings by Pierre Puvis de Chavannes, an artist she greatly admired.

This painting shows us the real life of someone who is a fairly well-known painter of the Impressionist era. Although comfortably upper-middle class, and not overly burdened with the daily household tasks associated with women, Mary MacMonnies was nevertheless restricted in her freedom, and still required to be a needlewoman, even though she had many other creative outlets.

The Young Seamstress

Adolphe-William Bouguereau's *Young Seamstress* is a peasant girl, just a child really, seated on a worn stone step. She is clad in a simple black skirt and white peasant blouse. A large orange-colored cloth is draped across her lap; she clutches it with her left hand as her right is poised with needle and thimble, captured mid-stitch. Her hair is somewhat unkempt and her gaze is averted; she seems lost in thought. The young seamstress wears no shoes, and her feet look hardened by lack of protection. Behind her are the unforgiving stone blocks of a building, and small weeds poke up through cracks in the cement. Bouguereau's sympathetic depiction of one of society's cast-off children evokes sympathy from the viewer; one can only speculate at the hardships of her young life.

Bouguereau was a well-known and respected painter in nineteenth-century France. He began his career with Academic Classical painting, the only kind suitable for public spaces, and he received enough commissions to support himself for a time. He also painted pictures more appealing to the general populace in the genre style. His subjects were often idealized and sentimental, painted with photographic verisimilitude.

Sometimes classified as a Pre-Raphaelite, Bouguereau is more accurately a Neo-classicist. Popular with the bourgeoisie and the foreign, particularly the American, market, his work included such secularized religious scenes as mothers and children, shepherds and shepherdesses, idealized Italian peasants, nudes, and Classical themes.

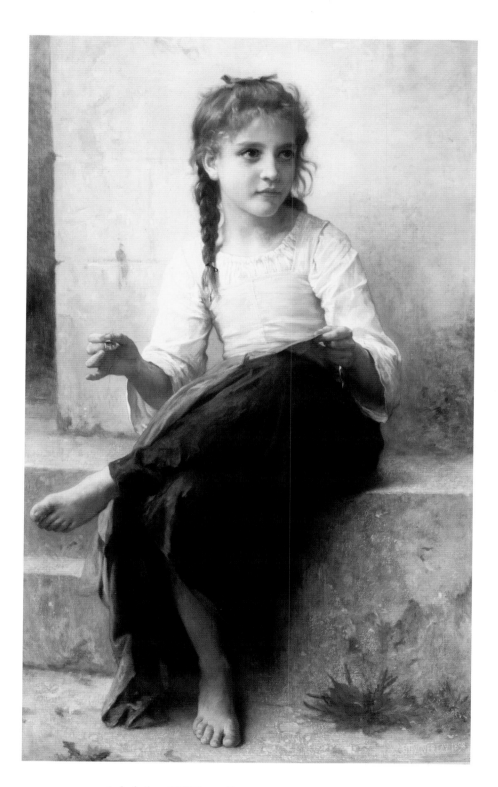

Adolphe-William Bouguereau, 1825–1905
The Young Seamstress, 1898
LOCATION UNKNOWN

The Artist's Son Jean Renoir Sewing

This charming painting of the young Jean Renoir, aged about five or six, is unique among "stitcher" paintings in that it is one of the very few that depicts a male child sewing. Renoir painted numerous pictures of his children, particularly this child, Jean, who was the middle of three sons. Renoir has also portrayed Jean playing with toy soldiers, finger painting, playing with blocks, reading, cooking, and engaged in many other activities, sometimes with his mother, sometimes with his nanny, Gabrielle.

In this painting, Jean is pictured sewing on a white fabric. Closer examination reveals it to be some sort of embroidery and, if that is the case, he is indeed a very precocious child, because most children of that age do not have the dexterity to execute such fine work. This is even more true of boys, and yet Jean seems intent on his stitching.

He is clad in a light-red smock, a style that children of both sexes of that era wore. His golden-red hair is tied back with a yellow bow. In Jean Renoir's biography of his father, he records that his father was convinced that hair was there to protect the delicate heads of children and should be allowed to grow long for that reason.[1]

Jean Renoir (1894–1979) grew up to become a famous French film director, and his films have achieved almost a cult status among Americans. He received La Croix de Guerre for service in the First World War, and eventually emigrated to the United States during the Second World War and became an American citizen.

1 Jean Renoir, *Renoir, My Father*, transl. Randolph and Dorothy Weaver, New York (The New York Review of Books) 1958.

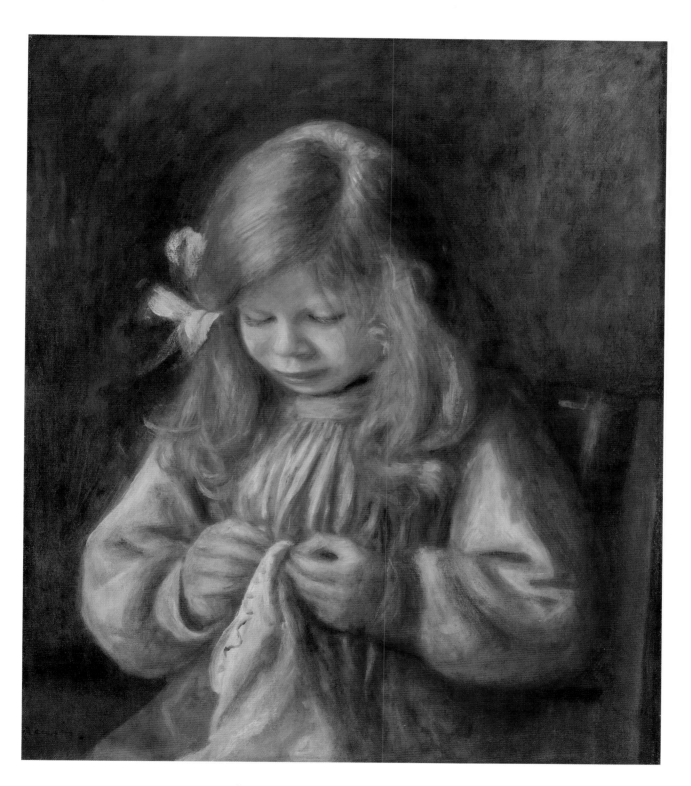

Pierre-Auguste Renoir 1841–1919
The Artist's Son Jean Renoir Sewing, 1899–1900
THE ART INSTITUTE OF CHICAGO

Mother and Child
Young Mother Sewing

The pastel shown below, *Mother and Child*, is a study for the painting *Young Mother Sewing*. Mary Cassatt has pictured a woman absorbed in her sewing, while her young daughter looks away. The woman appears to be working on a small garment, perhaps for the little girl, or she may be just hemming a napkin or handkerchief.

The mother wears a black and white striped dress with voluminous skirts and wide sheer cuffs at the elbow; the vivid stripes are broken up by the pale blue of her apron. Her hair is piled up on her head, easy to manage when one is busy with children and household tasks. The child is dressed in an all-white, fairly elaborate dress, not too practical for an active child, but perhaps chosen specially for the portrait.

Mary Cassatt, 1844–1926
Mother and Child, c. 1900
PRIVATE COLLECTION, PARIS

In the study, the child appears to gaze into space. However, in the painting, she stares attentively at the viewer. In the study, the child's arms are tucked under her body, but Cassatt changed them for the final painting, in which the little girl leans on her palm, one finger in her mouth, and the others curled against her cheek. The left hand is also visible holding her elbow. In the study, the child appears a little distracted, but in the painting she appears to consider the work of the artist more interesting than that of her mother.

Unusually in Cassatt's work, there is a hint of the outdoors, in the heavily wooded area and small yard seen through the window. In the final painting, Cassatt has embellished the setting with a blue and white vase full of orange flowers, an additional focal point that adds a further touch of femininity and pleasing ambience to the scene.

The existence of both these works gives us an insight into Cassatt's working method, and the function of the study in the realization of the final painting.

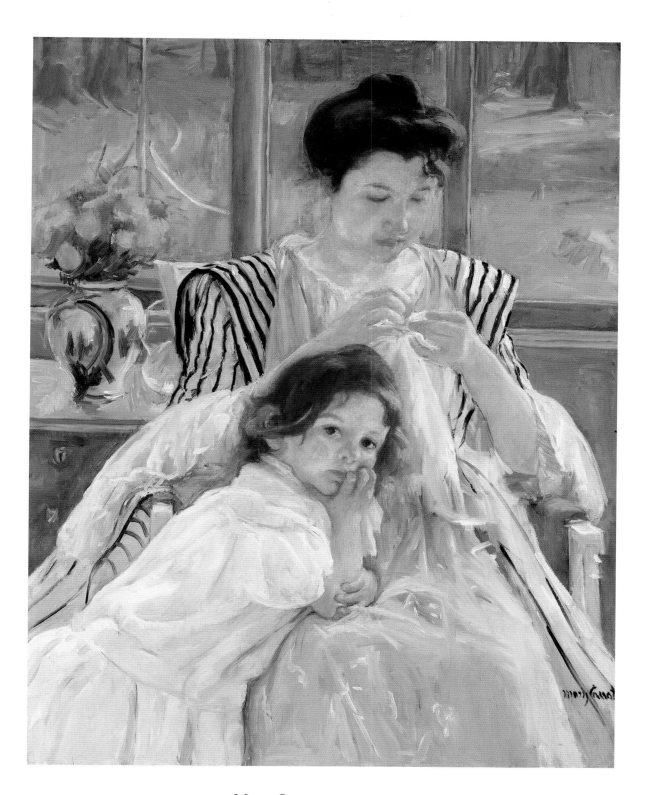

Mary Cassatt, 1844–1926

Young Mother Sewing, 1900

THE METROPOLITAN MUSEUM OF ART, NEW YORK

Portrait of a Girl Sewing

Here is another of the many paintings of needlewomen by Renoir, rendered in the pale corals and pinks so favored by this artist. An unidentified young woman sits in a comfortable chair, busy with her embroidery and enjoying the quiet moment. She wears a pinkish smock-type gown, perhaps a dressing-gown, with a contrasting color at the neck. Her strawberry-blonde hair is bundled up just above her neck, and her head is bent in the characteristic posture of the needlewoman.

Unusually in such paintings we can actually see the embroidery. The stitching itself is elaborate, a long panel full of colorful flowers, with the work well on its way to being finished. The stitcher does not have her work stabilized on a frame, and the position of her hands suggests that it might be surface embroidery, although we also do not see any hint of a hoop. However, the appearance of the finished work is more indicative of canvaswork. Around the end of the nineteenth century, canvaswork, or needlepoint as we know it today, was often worked "in hand," rather than on a frame.

Although the model is unidentified, it seems as though she must be a middle-class woman, with time to work on a decorative item for her household, rather than a servant girl given the task of mending or other plain sewing. Renoir and the other Impressionists often included embroidery in their paintings to suggest their appreciation of the artistic life.

Nothing in the background of this painting tells us much about the subject. The interior is quite indeterminate, except for the upholstered chair. Outside we see a neighboring building and the abundant foliage of a well-tended garden.

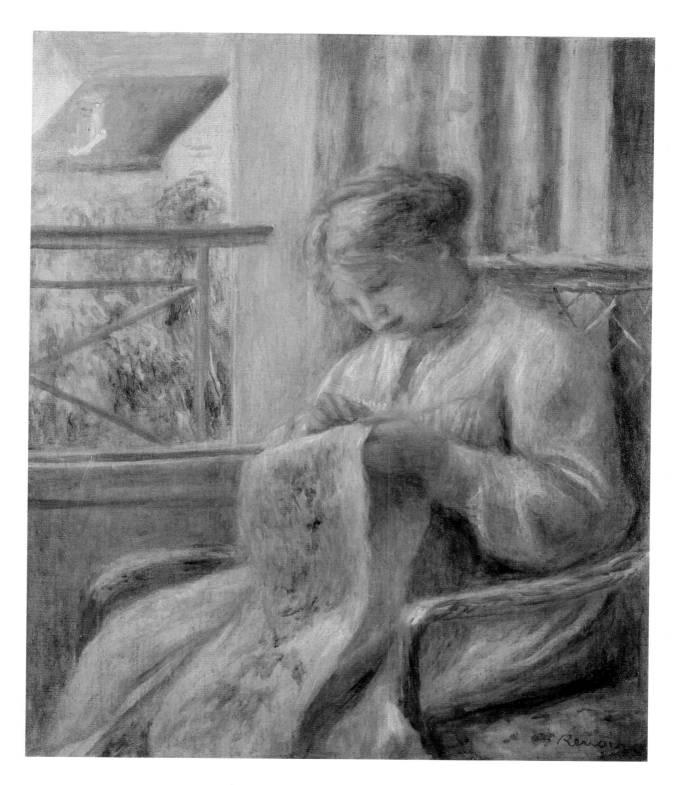

Pierre-Auguste Renoir, 1841–1919
Portrait of a Girl Sewing, 1900
ST. LOUIS ART MUSEUM

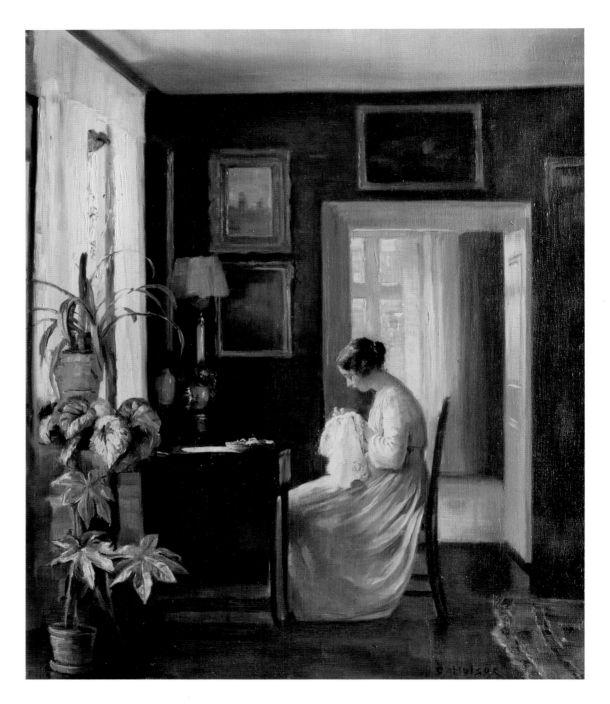

Carl Holsoe, 1863–1935
Woman Sewing by a Window, c. 1900
PRIVATE COLLECTION

144

Woman Sewing by a Window

This elegant painting of a needlewoman is by the Danish Impressionist Carl Holsoe. He depicts a young woman seated at a small table in front of a sunny window, who is completely absorbed in her embroidery. Her light-colored dress and well-tended hair suggest that she is a woman without too many household tasks.

Holsoe uses a typically somber palette; most of the elements of this painting are in shades of brown and muted greens. The exceptions are the subdued colors of the rug, visible at the lower right, and the hints of brightly colored balls of yarn in the tray on the table.

The interior indicates that this is a prosperous household, with its mahogany furniture, the paintings on the wall, and the elegant vases and lamp in the corner of the room. Sunshine streams through two windows and both are draped with airy sheer fabrics to admit the light.

The light plays across the woman and her embroidery, highlighting her work, which is placed centrally in the composition. The leaves of the houseplants also capture the rays of light and act as a decorative element. Their shapes seem to be echoed in the embroidery.

Holsoe's work, particularly this painting, reflects the influence of a much earlier genre painter, Jan Vermeer (see pp. 26–27). Here, Holsoe adopts Vermeer's convention of the single figure in an interior, with light streaming in to illuminate the subject.

Woman Sewing

Woman Sewing is a genre painting by the Danish Impressionist Anna Ancher. Here she has painted an unknown woman with her head bent over her needlework. It appears that she is making a dark skirt or similar garment, probably using a sewing machine, as one is pictured in front of her. The depiction of a sewing machine is unusual in paintings of needlewomen, but at the time of this painting it was a modern invention, and considered to be a treasure because of the reduction in workload it offered to (mostly) women.

The machine is sitting on a rather rough-hewn table, which is tucked under a windowsill. A spool of thread sits in front of the machine, and the woman's scissors are to the right of it. On the windowsill we can see a dark rectangular object, which may be a small book, possibly a Bible, or a box of pins.

Also in the window is a dark vase with a large flower arrangement. Light streams through the window, providing light for the seamstress, as well as casting a shadow from the leaves on to the rear wall, thus creating an area of visual interest.

Anna Ancher, her husband Michael, and several other painters established an artist colony in Skagen on the north coast of Denmark. They lived there for several years, painting in the Impressionist style. Their subject-matter was occasionally landscapes or seascapes, but more often they painted each other's activities, which included a few men as well as women at their needlework. Other paintings show people walking on the beach, playing with their children, having picnics, fishing, and going to church.

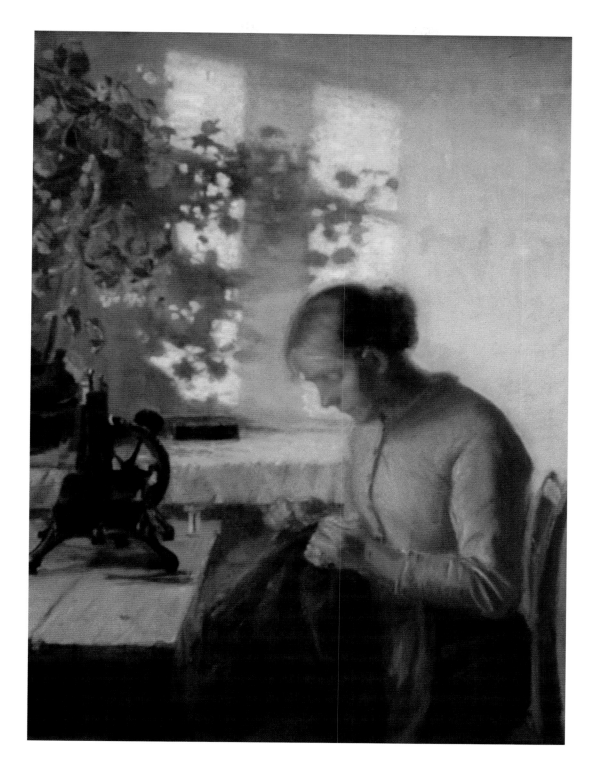

Anna Ancher, 1859–1935

Woman Sewing, c. 1900

RANDERS KUNSTMUSEUM, DENMARK

Madame Arthur Fontaine
(Marie Escudier)

Mme Arthur Fontaine, whose maiden name was Marie Escudier, was the wife of a successful Parisian businessman, and both were active in French intellectual circles, counting among their friends the writers, musicians, and artists of the period.

In Odilon Redon's pastel portrait of Mme Fontaine, she wears a yellow gown with a diaphanous and luxuriant bertha, or wide, deep, cape-like collar, of exquisite lace. Wide, flowing lace cuffs further enhance the outfit. The color of the gown complements the sitter's dark hair, but the choice is unusual for portraits of this type; rarely does one see a woman of this era clothed in such a radiant daffodil hue. Marie's hair is piled upon her head, as was the style of that period, when only young girls wore their hair flowing down their backs.

Marie holds in her hands a large embroidery hoop that appears to be quite heavy, and resembles a quilting hoop. Her embroidery flows from the hoop to reveal finished flowers and leaves that repeat the brilliant yellow of her gown. There is a lacy edge, so perhaps this is a pillow case, or possibly a small tablecloth. The experienced embroiderer knows that it would be difficult to hold such a large hoop unsupported in this position for any length of time. However, closer examination reveals that the hoop is attached to a stand, barely visible at the lower left but accurately portraying the work. We do not know whether Mme Fontaine was truly an accomplished needlewoman, or whether Redon employed these props and the pose to show that she was the model of a virtuous and genteel woman.

Surrounding Mme Fontaine are blue and periwinkle flowers, which complement the yellow of her dress. They are displayed in a large blue vase, and arch over her head in a way no simple flower arrangement could ever achieve. This effect gives the woman an almost saintly appearance.

Redon was much admired for his flower paintings, executed in radiant colors in both oils and pastels, as well as for his visionary works and mythological scenes.

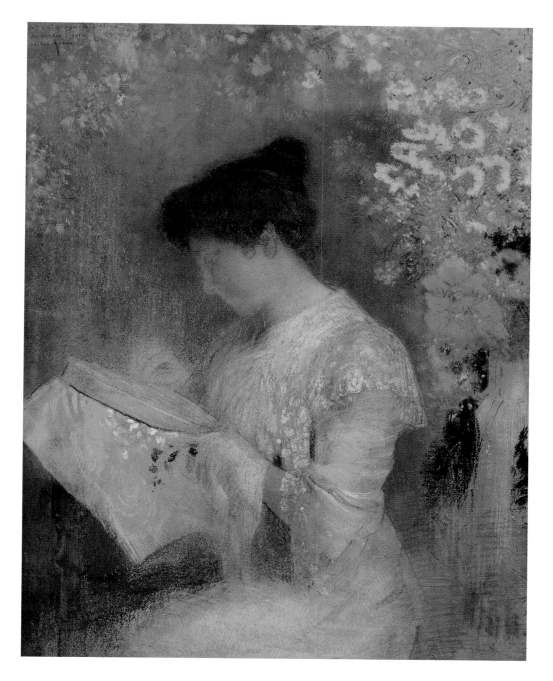

Odilon Redon, 1840–1916

Madame Arthur Fontaine (Marie Escudier), 1901

THE METROPOLITAN MUSEUM OF ART, NEW YORK

The Embroiderers

In this painting, three young women work intently in an ambiguous setting; the entire scene is suffused in warm coral-colored light. Once again Renoir has portrayed one of his favored subjects, the needlewoman, but, in this painting, he is not recording the solitary, meditative endeavors of a well-to-do young woman. Rather he depicts working-class girls, possibly employed in producing objets d'art for purchase by the bourgeoisie. These models are dressed more casually than in Renoir's other embroidery paintings; indeed, their loose-fitting garments allow them the freedom of movement and more casual postures necessary for day-long stitching.

One girl hovers over the needlework frame, contemplating her project and perhaps discussing it with the woman in the white gown. In the background, a third woman appears to be examining the stitching on another item, possibly checking the quality of the work, making sure that no stitches have been missed.

All three women have their hair casually tied back and, as is so often the case in Renoir's work, the faces of the women are flushed; whether this flush is from their labors or the rouge they wear, it is hard to tell. The girl at the embroidery frame wears a striking blouse of a sheer fabric, with a wide soft neckline and blue ribbons trimming the collar. The woman in white has smocking at the neckline of her blouse, and both women have wide ruffles at their elbows, a popular style but one that must have interfered with their embroidery. The woman in white also wears a little jewelry: two rings, small earrings, and a necklace.

Perhaps these three are what the French called grisettes, working-class women who were self-supporting and unfettered by the mores of bourgeois France. In this era it was felt that needlework was an honorable and virtuous way for a woman on her own to earn a living.

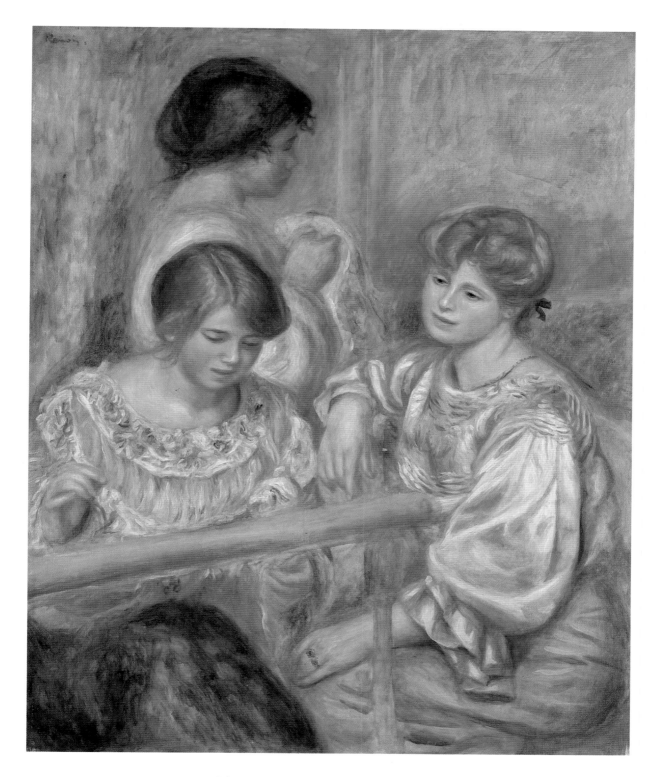

Pierre-August Renoir, 1841–1919
The Embroiderers, 1902

BARNES FOUNDATION, MERION, PA

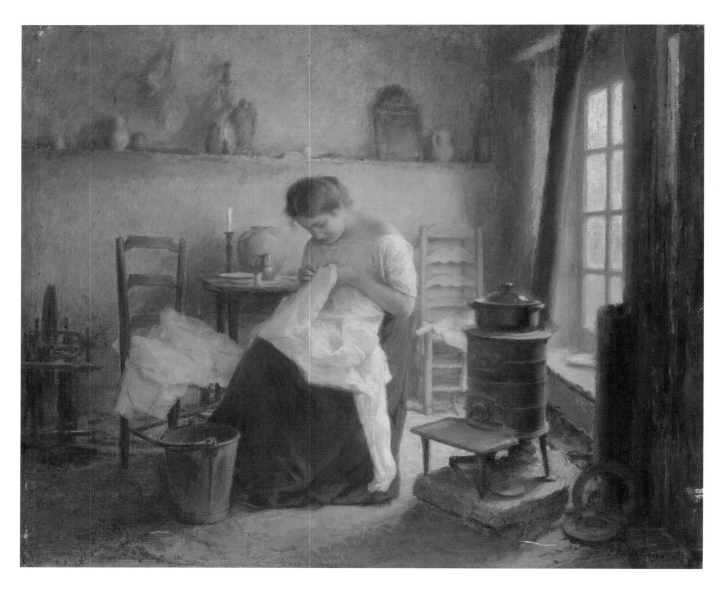

Léon Delachaux, 1850–1919
The Laundry, Interior, 1905
MUSÉE D'ORSAY, PARIS

The Laundry, Interior

The Swiss artist Léon Delachaux has painted a woman sitting quietly alone, in the middle of a room that he has named as the laundry, in this bleak depiction of a washerwoman's life. There are no baskets of unwashed linens, no clothes hanging on a line; instead the model is engrossed in mending a shirt, it seems, for a long sleeve hangs off one side of her lap.

Mending was only one aspect of the gigantic chore of laundry. In those days, water had to be hauled from a creek, pond, or well. Then wood had to be collected and a fire made. The water was heated, and then the washing could finally begin. It was difficult, arduous labor that took up almost the whole of Monday. On Tuesday the ironing was done, and on Wednesday the mending.

Mending may have been the most relaxing task of all. One could do it while seated; most likely one did not work up a sweat; it was clean work, and possibly even pleasant, although the laundress in this painting seems rather downtrodden.

The setting is quite cheerless; the floor is of dirt, and the beams holding up the house project across the window, but at least there is a window. The timbers are rough, as is the stucco of the wall, but the laundress has some decent, if hard and straight, chairs to sit in, and a small table for her sewing supplies. Even a swift sits almost hidden in the corner. And there is a stove for warmth when the days are cold.

The colors of the painting are subdued. The scene is rendered in browns and beiges, with the exception of the mending.

Women Crocheting
(Femme faisant du crochet)

D. Lucie Cousturier has painted a woman engrossed in her task of crocheting. We cannot tell what she is making; it may be a fine lacy edging for a handkerchief. The woman wears a casual day-time dress, with a square neckline and elbow length sleeves ending in a wide flounce. Her hair is piled on top of her head, giving her a rather severe look. It seems that she is anxious to finish her project, as her shoulders are lightly hunched and she appears to be working intensely; she does not lounge against the blue sofa on which she sits. To her left is a highly patterned sofa pillow, possibly done in needlepoint. Parts of two paintings are behind the subject, and we may surmise that these are other works by the artist.

Here we have a very traditional subject-matter, the needlewoman, a theme explored by the Impressionists, but now interpreted in a new modern painting style that evolved from Impressionism. The style is a variation on pointillism, where small daubs of paint are arranged with careful consideration of color interaction to create the scene. This painting is pointillist in technique, and is worked in yellow, blue, and blue-green with small accents of orange. Although Cousturier was employing an innovative technique, she nevertheless chose a familiar subject.

Cousturier was not only an artist but also a writer, and she compiled the first monograph on Paul Signac, having been his pupil. She is also noted for her forward thinking and writing on race relations in France.

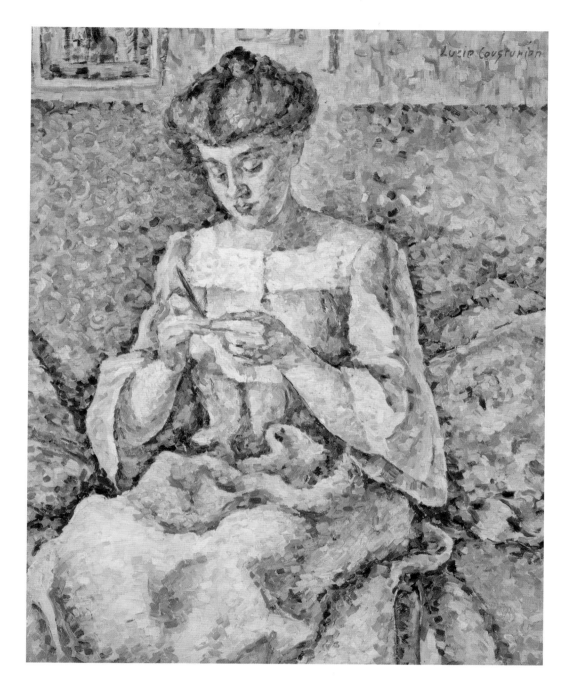

D. Lucie Cousturier, 1887–1925
Woman Crocheting, 1908
(*Femme faisant du crochet*)
MUSÉE D'ORSAY, PARIS

Salish Woman Weaving

Emily Carr is one of Canada's most famous painters, which is unusual because she was a woman painting in the late nineteenth century, and even more so because she lived in western Canada and concentrated her work on the indigenous peoples, called the First Nations. Carr is best known for her paintings of First Nation life, and in these works she sometimes included their totem poles, thereby providing what is often the only record we have of these icons of indigenous life. Because totem poles were constructed for celebrations and special gatherings, the native people did not think to preserve them, and it is thus only in Carr's paintings that we have documentation of their existence.

Many of Carr's paintings were of a group known as the Salish, an indigenous American people living in the Pacific Northwest on both sides of the Canadian and American border. In *Salish Woman Weaving* there are no totem poles, only a simple representation of a woman working at her weaving. She holds in her hand a very small loom made of birch bark, and one may assume that the product will be a decorative item called a plaque, which was used for ceremonial purposes. In her right hand she holds some sort of small shuttle.

The woman's clothing is simple: she wears a dark dress covered by an orange apron. One dark shoe peeks out from beneath the hem of her dress. A small bracelet is her only adornment; even her hair is caught back into some kind of knot at the nape of the neck.

The walls of the interior appear to be plastered with mud; they have the color and the look of handplastering, but there is a window, so this is no primitive dwelling. The stitcher has placed herself by this source of light to work. On the edge of the table in front of the Salish woman there appears to be a small sewing box, with threads trailing out of it.

This painting again shows how women of all periods, of all nations, of all stations in life, have participated in some kind of needlework.

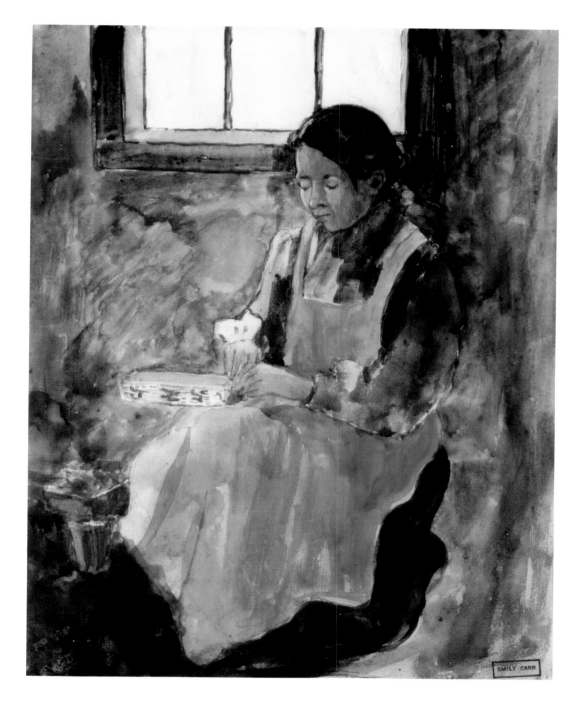

Emily Carr, 1871–1945
Salish Woman Weaving, 1909
BRITISH COLUMBIA ARCHIVES, VANCOUVER, CANADA

The French Tea Garden

In *The French Tea Garden*, also known as *The Terre-Cuite Tea Set*, the American Impressionist Childe Hassam has painted an elegant setting for an afternoon tea in the garden. Against a backdrop of flowering shrubbery, a woman sits, absorbed in her needlework and, apparently, waiting for someone to join her. She wears a white summer dress, loose and full of ruffles, which are trimmed with lace. Her hat is striking, of marine blue, and is embellished with flowers; its long streamers fall gracefully over her shoulders.

The table is set with dark-brown-and-blue glazed china. The alternative title for this painting, *The Terre-Cuite Tea Set* (*terre-cuite* is French for 'terra-cotta') suggests that this is handmade pottery.

It is not clear whether the woman is really sewing, or merely picking up the napkin before taking her tea. Closer examination, however, reveals a thimble on the middle finger of her left hand.

On the left of the painting Hassam has included a stone wall and a gate with a shingled roof; through it we see an adjacent garden with orange and red flowers and trees. The lilies on the table repeat the orange and bring it into the center of the composition, which complements the blue of the woman's hat.

This painting is bathed in a brilliant light characteristic of Hassam's Impressionist technique; with its subject-matter, its brushstrokes, and its capturing of an ephemeral moment all typical of this style.

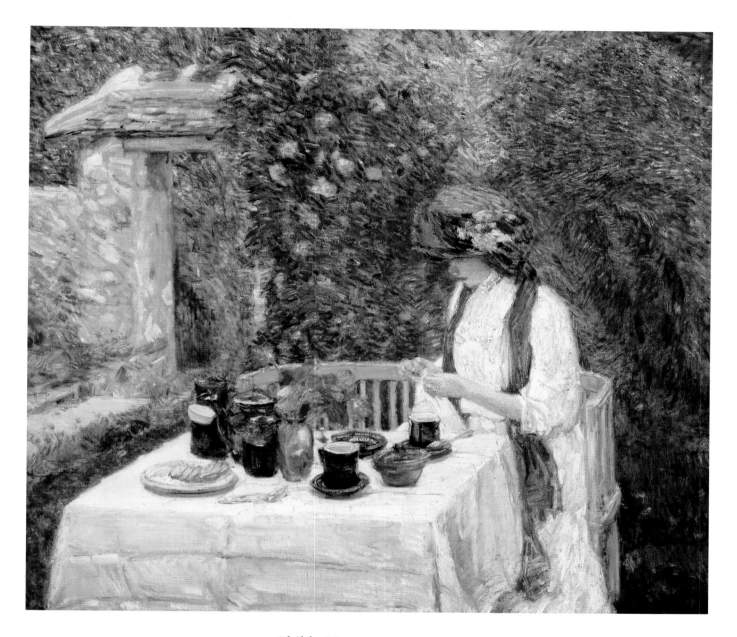

Childe Hassam, 1859–1935
The French Tea Garden, 1910
HUNTER MUSEUM OF AMERICAN ART, CHATTANOOGA

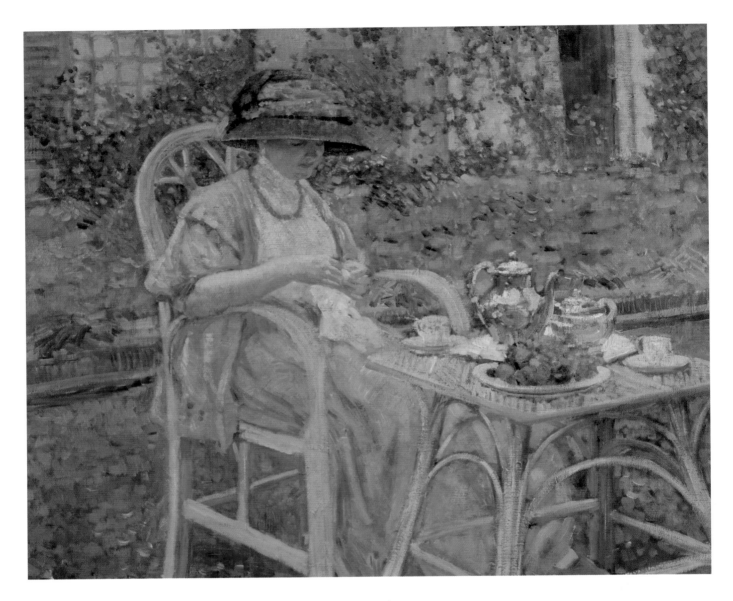

Frederick C. Frieseke, 1874–1939
Tea Time in a Giverny Garden, 1911
TERRA FOUNDATION FOR THE ARTS, DANIEL J. TERRA COLLECTION, CHICAGO

Tea Time in a Giverny Garden

Tea Time in a Giverny Garden, also known as *Breakfast in the Garden*, is a classic Impressionist painting depicting the activities of the bourgeois woman of the late nineteenth century. Here Frederick Frieseke, an American Impressionist and one of Monet's circle, has painted his wife Sarah sitting comfortably in a large green wicker chair with needlework in hand, and her tea laid out in front of her.

This is conventional subject-matter for the Impressionists: an everyday activity, nothing noble about it, just pleasant passing of time in a beautiful setting. But it demonstrates that Frieseke's wife was a woman of leisure, well bred and accomplished in the important literacy for the Victorian woman. She is casually clothed for the time, and the purple hat modestly conceals part of her face—or perhaps it is just to protect her from the sun.

Behind Sarah is a low stone wall, full of foliage not in bloom, and a building that is probably their home. Some reddish flowers, maybe clematis, surround the doorway, and this red is reiterated in the necklace worn by Sarah. These small touches of red enliven a composition almost totally in cool greens and blues, a shady feeling on what might be a sunny day.

On the table we see a silver pot for coffee, and one for tea, two cups, and a platter of fruit. Perhaps the second cup alludes to the artist himself; his statement of his presence in the painting.

Frieseke's painting is quite similar, certainly in subject-matter and setting, and even in color scheme, to *The French Tea Garden* by Childe Hassam (see pp. 158–59). The paintings were done at around the same time, and both artists studied with Monet, so it is possible that they were familiar with one another's work.

Two Women Embroidering on a Veranda
(Deux Femmes brodant sous une veranda)

Edouard Vuillard was a member of the Nabis, a movement of Post-Impressionist artists who favored an expressive use of color. Here Vuillard has painted two women seated on a veranda, both intent on their needlework. Dominating the scene is the woman in yellow; she is in the center of the composition, with a strong vertical line, almost an arrow, in the background, pointing at her. Likewise, the yellow of her gown is repeated in the stained glass behind her.

The other woman sits opposite her, half-turned to the viewer, and she wears a pale-peach gown. Vuillard has repeated this color in a chair in the background and, in a different tone, in the color of the sky. The touches of red in the painting almost reinforce the yellow, and also complement the gray-green that dominates much of the top half of the painting. Vuillard has depicted in detail a tiled floor and the woven arms and seat of the chair in the foreground.

It is difficult to perceive exactly what the women are working on. The woman in the peach gown appears to have a crochet hook in her hand, and it is possible that the woman in yellow is knitting, although the title of the painting suggests otherwise.

Edouard Vuillard, 1868–1940
Two Women Embroidering on a Veranda, 1912
(Deux Femmes brodant sous une veranda)
MUSÉE D'ORSAY, PARIS

John William Waterhouse, 1849–1917
Penelope and the Suitors, 1912
ABERDEEN ART GALLERY AND MUSEUM, UK

Penelope and the Suitors

This painting is a treatment of the same theme as Romare Bearden's *The Return of Ulysses* (see pp. 186–87). It focuses on Odysseus's faithful wife Penelope, who awaits his return and is pursued by eager suitors who share the common belief that Odysseus is dead. Penelope, however, is convinced that Odysseus still lives, so she devises a scheme involving weaving to hold off the suitors.

Penelope undertakes the weaving of a shroud for her aging father-in-law, Laertes, King of Ithaca, and tells the suitors that she cannot possibly consider remarriage until she has finished this task. She spends her days weaving the shroud, but at night she secretly unravels her work, thus making little or no progress for almost three years. Eventually Odysseus returns, defeats the suitors in a contest, and reclaims his ever-faithful Penelope.

John William Waterhouse is sometimes considered to be a Pre-Raphaelite painter, but he is more accurately described as a Romantic Classicist, devoting himself to ancient themes and people. Here he has depicted Penelope in an elegant studio, with rich carpets and beautifully painted walls. The wooden columns are fluted and complex, and even the loom itself appears to be of the finest woodwork.

It is difficult to ascertain the appearance of the shroud; the little that is visible seems to be heavily patterned and brightly colored. Penelope wears a reddish Grecian gown, loose and flowing, but caught at the waist with a figured sash. The two other women are similarly dressed, with their hair styled in ways that are copied from Grecian urns. A large swift for winding the yarn either after it is spun or to hold it as it is being wound into a ball sits beside Penelope, and she holds the shuttle in her hand as she bites off her piece of thread.

The determined young suitors hang through the open windows, with flowers and jewels to tempt her; one plays an ancient instrument. The most prominent of the gentlemen wears a laurel wreath, demonstrating his recent victory in some kind of contest. He thrusts his roses forward, but Penelope ignores them and him, and attends to her task.

Frederick C. Frieseke, 1874–1939
Torn Lingerie, 1915
ST. LOUIS ART MUSEUM

Torn Lingerie

This boudoir painting by the American Impressionist Frederick Frieseke portrays a woman whose dress is richly embellished with pink ruffles and lace. The model is probably the artist's wife, Sarah, dressed as if for a dance, with her pink ballet slippers dominating the painting. Her jewelry—a necklace, earrings, and a ring—are all clearly detailed. Her gown appears to be satin overlaid with a sheer fabric, perhaps chiffon, and about her shoulders she wears a lacy shawl.

This outfit, however, may be only her lingerie, as suggested by the title, and perhaps another garment is to cover all this finery. Ladies of that era wore many layers of petticoats under their gowns. But then why the ballet slippers? It would have been unusual at that time to have quite so much leg on display, too. The model seems to be wearing tights, which would be appropriate for a performer. She seems to be wearing too much make-up for the virtuous bourgeois woman. The model perhaps finds herself in a situation familiar to most women: having partially dressed, she discovers that her gown needs mending.

There are many other feminine touches in this painting: the flowered wallpaper, the tapestry chair, the highly patterned oriental rug, and the dressing table with its ruffled lace tablecloth.

Frieseke won several prizes with this painting; it was applauded by critics and the public alike, and remains one of his most identifiable and revered works almost a hundred years after its creation.

Child Sewing

Joseph Raphael's rendering of a young girl intent on her sewing is unusual in that he has employed a style associated with Post-Impressionism and Modernism, yet he has chosen a very traditional subject.

Raphael has pictured a young girl, aged perhaps ten or eleven, slumped in a straight-backed chair with her dress hiked up above her knees. She holds her sewing practically at her nose. Her long thin legs are askew, and she is not sitting in a polite manner. A broad-brimmed straw hat is pulled down to hide most of her face. She is apparently stitching out-of-doors in full sun, if we are to judge by the hat, the flowers, and the brightness of the scene.

She sits beside a table on which there is a large book, and some sewing implements. A doll lies on the ground nearby, perhaps tossed aside in favor of the new endeavor. The book could be a Bible, a traditional element in such scenes. The artist may be employing the book, the sewing, and the doll to signify the journey from childhood to womanhood, with the book indicating learning, the sewing the obligations of the adult woman, and the doll the not yet abandoned childhood. Certainly the brilliant flowers make this seem a happy transition.

It is impossible to determine the nature of the child's sewing and, were it not for the title, one could not quite be sure that the model is actually stitching.

The artist's choice of color is exuberant in his use of brilliant blues, and in the expressionist colors employed for the flowers in the foreground, and the tree to the left, which are applied with bold and energetic brushstrokes.

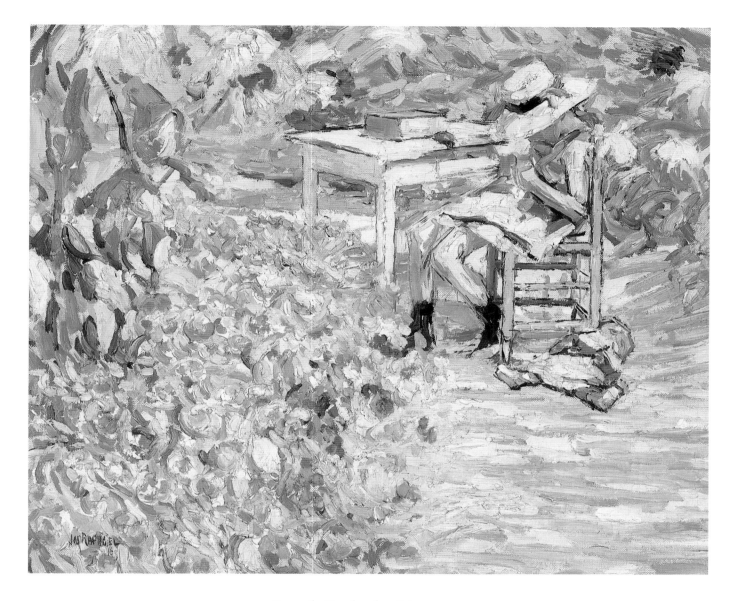

Joseph Raphael, 1869–1950
Child Sewing, 1916

"I am Half Sick of Shadows," said the Lady of Shalott

Alfred Lord Tennyson's poem "The Lady of Shalott" (1842) tells of a woman cursed to spend her days in a tower, forbidden even to look out of the window. Instead, she may only view reality in a mirror, and must reproduce what she sees in her weaving. One day she sees Sir Lancelot riding over the bridge into Camelot and, frustrated and bored with her austere existence, she dares to look directly out of the window at the knight. The curse is enacted; her weaving unravels. She goes down to the river and finds a boat, floats in it down to Camelot, and dies along the way.

Tennyson's poem reflects the condition of the Victorian woman who is confined to her home, and lives life only vicariously; the Lady of Shallot symbolizes the evil that will befall the woman who defies the dictates of society and attempts to break free.

The Lady of Shalott was a favorite subject-matter for the artists of the Pre-Raphaelite Brotherhood (including Dante Gabriel Rossetti, John Everett Millais, and William Holman Hunt) and, although Waterhouse was not a member, his style is associated with them. Waterhouse painted no fewer than three renditions of the Lady of Shalott, and there are several more by other painters of the time.

In *"I am Half Sick of Shadows," said the Lady of Shalott*, which is the third of Waterhouse's interpretations, the Lady stretches wearily from her labors over the weaving. Over her shoulder the viewer can see the towers of Camelot, two lovers walking beside the river, and Lancelot himself riding over the bridge; these are all reflected in the mirror, the only medium through which the Lady of Shalott can experience life. Waterhouse captures the moment before the heroine activates the curse, in her last secure moment before going to her doom.

The surroundings depicted here are sumptuous, but the weaving is all this tragic figure has in life, except for the fleeting glimpses of life outside the tower.

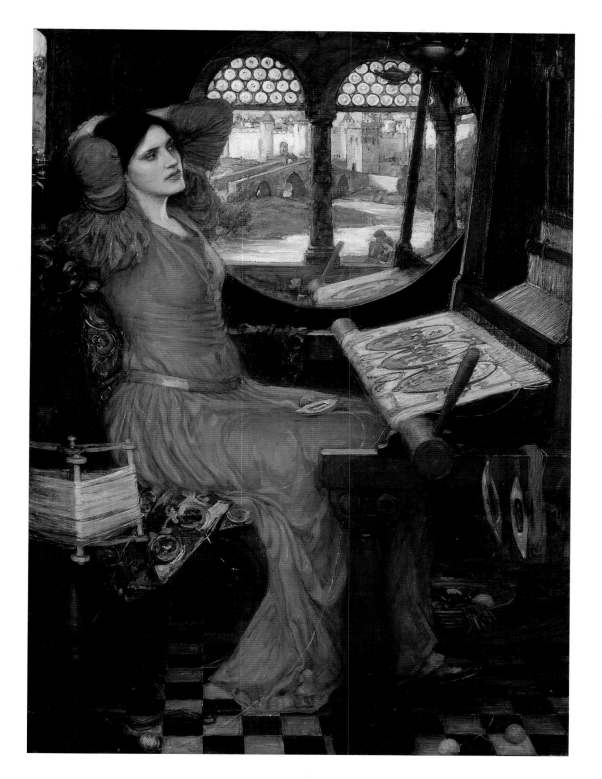

John William Waterhouse, 1849–1917
"I am Half Sick of Shadows," said the Lady of Shalott, 1916

Willard Leroy Metcalf, 1858–1925
My Wife and Daughter, 1917–18
TERRA FOUNDATION FOR AMERICAN ART, CHICAGO

My Wife and Daughter

In this painting, the wife and daughter of the American artist Willard Leroy Metcalf enjoy a quiet moment together on a pleasant summer afternoon. They are sitting on a wide day bed; Mrs. Metcalf is propped by a number of large colorful pillows, and her young daughter, too, has one behind her.

Both figures wear light summer clothing; the mother has a white skirt and pink striped blouse, and the little girl wears a pale-yellow smock. The child's legs are bare, except for the socks, and by this period children wore short dresses, although the mother's skirt still seems to be ankle length.

The woman regards her needlework intently, while the young daughter is engrossed in cutting paper; she may be making paper dolls.

Behind them are open doors and windows, bringing in the light and breezes of summer. The walls in this summerhouse are a cool blue-green, but are also mostly of glass. The foliage is lush, and a lake is visible in the distance.

It is an idyllic setting, and an endearing scene of a mother and daughter enjoying one another's company.

George Luks, 1867–1933
Knitting for the Soldiers: High Bridge Park, c. 1918
TERRA FOUNDATION FOR AMERICAN ART, CHICAGO

Knitting for the Soldiers:
High Bridge Park

In this painting, six women sit in a group, huddled on park benches, in a wintry setting. They represent a wide variety of ages; at least one woman has white hair and an older appearance, but two other women are accompanied by baby carriages, which suggests that they are younger. The fashionable hats and stylish, colorful coats of the women indicate that they are middle-class women who have come to the park for an excursion and some companionship. All six are knitting.

The ground is covered with snow and the trees of the park seem to embrace the women with their blue-gray presence. Sunlight flickers through the trees and in the clearing; but the day must be relatively mild, in spite of the presence of the snow; for otherwise, how could women be knitting without gloves, and how could they bring their babies outside?

The date and title of the painting tell us that the women are knitting for the troops in the Great War, a tradition handed down in America since Revolutionary times. It is thought that this painting was intended as a salute to the contribution of women to the war effort.

The artist, George Luks, was a member of the Ashcan school, a group of American artists who often painted slum life and outcasts, attempting to lend them dignity, or at least calling attention to their plight. *Knitting for the Soldiers* is thus a departure from Luks's usual subject-matter, and also from his customary somber palette. What might be considered a rather frivolous subject, women passing their time in the park, takes on a greater significance because of the chilly setting and the diligence of the subjects.

At least two other paintings exist with a similar subject-matter (Julia Alden Weir, *Knitting for the Soldiers*, 1918, Phillips Collection, Washington, D.C.; Odon Hullenkremer, *Navajo Girls Knitting for the War Effort*, private collection, Santa Fe, 1944), indicating that this activity was well known and well regarded by the people of America.

Woman at a Window in Figueras
(Femme à la fenêtre à Figueras)

It is unusual to find images of such a nineteenth-century subject as the needlewoman in the twentieth century, an era in which non-representational art reigned supreme, and yet here is one by the Surrealist Salvador Dalí. It is believed that he became obsessed with Jan Vermeer's *Lacemaker* (see pp. 26–27), and sought to create his own interpretation of the theme, employing as his model his sister Ana Maria. In a characteristic device, he has placed his model with her back to the viewer, which automatically directs the eye away from the subject and toward the scene in the background. Or in this case, to the lace that she is fashioning.

Dalí has posed his sister at a grand window with a wide sill, and shows her engaged in her lacemaking. She holds a bobbin in each hand, and more of them dangle from the sides of her work. Also visible on the sill are her scissors and a spool of red thread, a surprising choice since the working threads are white. The simple lace edging is placed on a red pattern; red was the preferred background for the display of lace in the early days of this art. Ana Maria wears a plain gray dress, her hair is bobbed, as was fashionable in the 1920s, and she wears a pink comb as decoration. Her arms and hands are monumental in form, reflecting the influence both of Classical art at that time and also, more specifically, that of Pablo Picasso on Dalí's work in the 1920s.

In the background beyond the woman is the town of Figueras, the place of Dalí's birth, and rising in the distance is a range of purple mountains with a small settlement on the far left hillside.

Dominating the town's skyline is the church, with its plain stucco walls and arched windows characteristic of Spanish architecture. The bell tower, especially, has an Iberian appearance. The church is surrounded by a wall, and more town buildings lie behind it along the street. A few sparse trees are visible, practically barren of leaves, which suggests that it is autumn.

A sign on the roof of the building across the street seems to say "Ford" and the colors are those of the auto company. The company was establishing itself in Spain in the 1920s, and the region of Catalonia, known for its industrial tradition, was of particular significance during this period of innovation. Dalí has demonstrated here the continuing existence of traditional domestic life amid contemporary change.

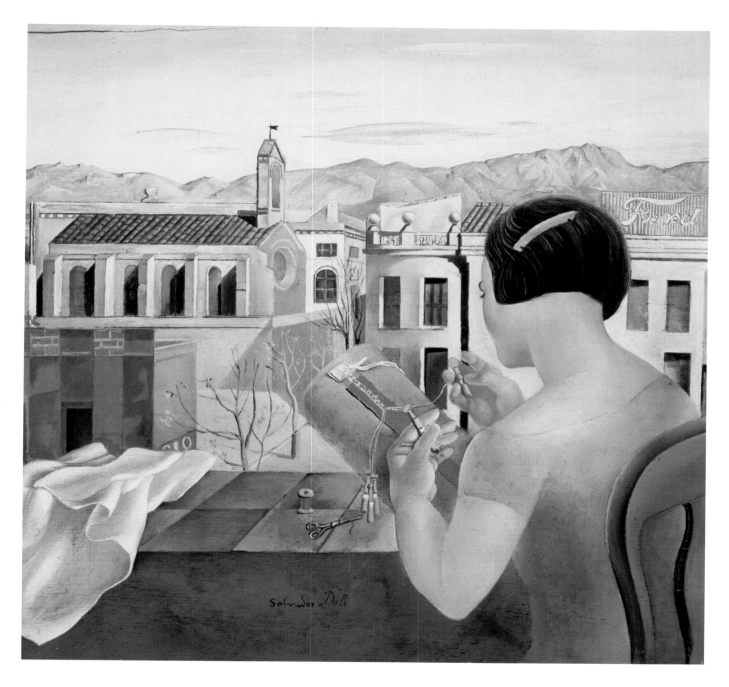

Salvador Dalí, 1904–1989

Woman at a Window in Figueras, c. 1926
(Femme à la fenêtre à Figueras)

COLLECTION OF JUAN CASANELLES, BARCELONA, SPAIN

Marie-Louise Richard, 1874–?
Sewing, 1926
LOUVRE, PARIS

Sewing

Miniature paintings on ivory were very fashionable in the early twentieth century. Here, Marie-Louise Richard has painted a young woman intent on her sewing, which does not appear to be anything more than some embroidery on a pillow case or tablecloth. She wears a blue garment, possibly a night gown or housecoat, and her hair is held back at the nape of the neck. A few curls escape to frame her face.

As is the case with many needlewomen, this model is pictured by a window, to afford her some light to work by, and to give the artist the opportunity to utilize light and shadow in the composition. A vase of pastel flowers is placed on the windowsill, softening the painting and adding some color. The needlewoman appears to sit sideways on a subtly figured sofa; the only other element depicted is the paneling of the wall behind her, and the sculpted wood of the window frame.

Miniature painting on ivory is a medium no longer practiced because of the restraints on the ivory trade, making such objects even more highly prized today.

The Terrace at Villerville

This "stitcher" painting is unusual because it is different in style from the Impressionist approach to the same subject half a century or so previously. This is a Post-Impressionist painting in the Fauve style; Fauve meaning "wild animals," a derogatory name given to the painters. They experimented with the arbitrary use of pure color, and painted scenes in expressive colors. In *The Terrace at Villerville*, Dufy has kept fairly faithful to realistic colors; the sky is blue, as is the ocean, and the foliage is mostly green. However, there is not much subtlety in the color tones, with the artist using paint in its purest values.

The colors employed in the interior, however, are more expressive. A brilliant blue light pervades the scene inside, in which the enclosed veranda, complete with Classical column, has windows overlooking the sea. Three women sit engaged in their handwork; they are dressed in cool blues and blue-violets. One woman has an almost violet complexion. The requirement to be an accomplished needlewoman carried over well into the twentieth century, as reflected here in 1930. The decoration in the room is spare, consisting of a gaily striped tablecloth and, in the corner, a large Chinese vase.

Dufy frequently depicted people at leisure, and his subjects included casinos, racecourses, and the promenades of fashionable resorts, which he represented with bold splashes of color.

Raoul Dufy, 1877–1953
The Terrace at Villerville, c. 1930
MUSÉE DES BEAUX ARTS ANDRÉ MALRAUX, LE HAVRE, FRANCE

The Weaver

Diego Rivera, along with his wife Frida Kahlo, is one of Mexico's most celebrated artists. He is best known for his starkly realistic murals of monumental size, many of which grace the government buildings of his native country, as well as other notable spots around North America. He was a known communist when this was an unpopular association, and such an affiliation was not an asset to his career. His works were often didactic, intended to inspire nationalistic pride in the Mexican people.

Rivera's *The Weaver*, however, does not seem to be making an overt political statement. He has painted a Mexican woman occupied with her work on a back-strap loom. This lightweight and portable device attaches to a wall (unseen in this picture), or even a tree if working outside, and the opposite end has a strap that goes around the weaver's body. This enables the weaver to put tension on the warp threads, thus allowing the shuttle to be passed back and forth to create the patterns.

The weaver is working on a long, narrow piece of fabric, which could be a stole, a window decoration, or perhaps even an altar cloth. The colors of the weaving are subtle and subdued, medium blue with some terra-cotta designs on a white background; these are not the colors one usually associates with vivid Mexican textiles. Much of the completed work is rolled up on her lap, but she continues to work on her project.

The woman wears a simple blue striped skirt, possibly handwoven, and a typical Mexican peasant blouse or *huipil*, cinched in with a wide sash that may also be handwoven. Her long hair is in a single braid down her back, the typical hairstyle of the indigenous women of Mesoamerica. The weaver is kneeling, which must be a difficult posture to maintain, but perhaps a lifetime of sitting this way keeps her knees supple.

To balance the painting Rivera has added two other elements, a yarn holder wrapped with red yarn and, in the background, a blue chest of drawers. He has employed a very subdued color triad of primary colors, pleasing in its simplicity.

Like Jean-François Millet before him, Rivera has depicted the peasant in a sensitive and sympathetic fashion, thereby conferring dignity to their lives and evoking understanding from the viewer (see pp. 66–69).

Diego Rivera, 1886–1957
The Weaver, 1936
THE ART INSTITUTE OF CHICAGO

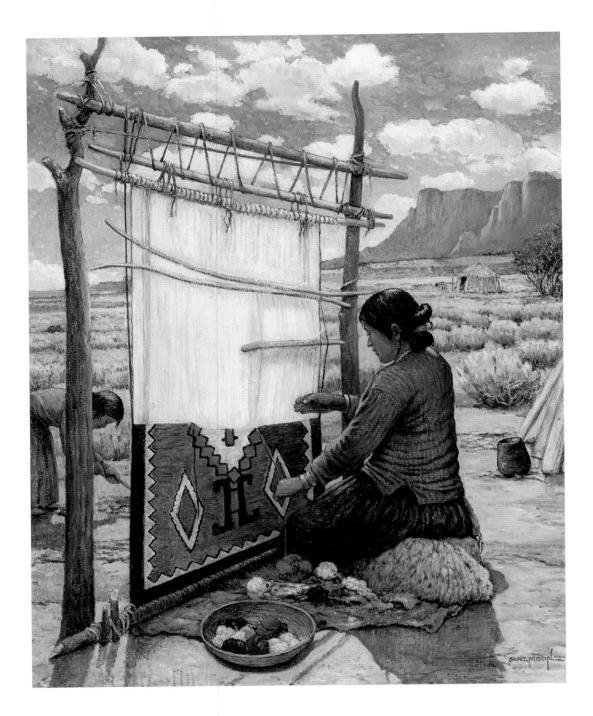

Carl Moon, 1878–1948

Navajo Weaver, c. 1937–43

Navajo Weaver

This painting by Carl Moon is highly evocative of the desert in the southwestern United States, with its crisp blue skies, its distant, hazy mesas, the piñon bushes dotting the landscape, and the hard, flat desert landscape. The artist has also captured the sensation of being able to see for miles.

The weaver sits in front of her loom, which is constructed of small tree trunks and dressed with small slender branches. The colors of the rug are the quiet tones of gray, brown, beige, red, and white that are so characteristic of the famous Navajo weavings. The Navajo are renowned for their exquisite rugs, employing patterns characteristic of their various sub-groups.

The woman wears a jacket that appears to be of leather, and a full skirt that will not `hamper her moving about in her work. She has the typical simple and elegant hairstyle of

the mature Navajo woman. Another rug covers the ground under the loom, and she is seated on a low stool covered with an animal skin. Balls of yarn are scattered at her feet and more are stored in the low basket beside her.

Another figure is partially hidden behind the loom: a man bending over the crops.

The Return of Ulysses

The timeless theme of the Ancient Greek hero Odysseus, here given his Latin name Ulysses, and his faithful wife Penelope, is revisited by the renowned African-American artist Romare Bearden. This artist is well known for his reinterpretation of Classical themes with black characters, and this is demonstrated in *The Return of Ulysses*.

Ulysses has been fighting in the Trojan War, and on his return journey he is beset by numerous temptations; he has been away for a total of ten years. He is determined to return to Athens, and his wife Penelope. Ulysses's father, Laertes, King of Ithaca, is dying, and Penelope is due to inherit the throne as Ulysses is presumed dead, but she cannot do so until she has finished Laertes's burial shroud. Meanwhile, suitors of every age and nationality besiege her with proposals, but she tells them she cannot consider marriage until the garment is finished. Convinced of Ulysses's return, Penelope weaves during daylight hours, and picks out all the weaving during the night.

Penelope is pictured as she sits at the loom, with a significant amount of her tapestry complete. Ulysses's ship is moored outside her window, and he and his men are rushing in to meet her. Bearden celebrates this happy reunion with brilliant colors, in his characteristic style.

Romare Bearden, 1912–1988

The Return of Ulysses, 1976

SMITHSONIAN AMERICAN ART MUSEUM, WASHINGTON, D.C.

FURTHER READING

Dolores Bausum, *Threading Time: A Cultural History of Threadwork*, Fort Worth (Texas Christian University Press) 2001

Thomasina Beck, *The Embroiderer's Story: Needlework from the Renaissance to the Present Day*, Newton Abbot, Devon, UK (David & Charles) 1995

Susan Burrows Swan, *Plain & Fancy: American Women and Their Needlework, 1700–1850*, New York (Holt Rinehart and Winston) 1977

Virginia Churchill Bath, *Needlework in America: History, Designs and Techniques*, New York (The Viking Press) 1979

Marianne Delafond and Marie-Caroline Sainsaulieu, *Les Femmes Impressionnistes*, Paris (La Bibliothèque) 1993

Baron Armel de Wismes, *The Great Royal Favorites*, Nantes (Artauld Frères) 1948

Mary Gostelow, *Art of Embroidery: Great Needlework Collections of Britain and the United States*, New York (E.P. Dutton) 1979

Rozsika Parker, *The Subversive Stitch*, London (The Women's Press) 1984

Elizabeth Wayland Barber, *Women's Work, the first 20,000 years*, New York (Hugh Lauter Levin Associates, Inc.) 1999

Rose Wilder Lane, *Woman's Day Book of American Needlework*, New York (Simon & Schuster) 1963

PICTURE CREDITS

INDEX

ACKNOWLEDGMENTS

Even though searching out paintings that depict stitchers has been mostly my solitary endeavor, there are a number of people who have made my quest possible and have enhanced the final product. My husband, Robert, has made it possible for me to take the time to go on this quest, and it is he who has provided the wherewithal to make many of my excursions a reality. In addition, he has accompanied me to numerous collections and exhibits when he would probably have rather been on the race track!

Next, I must express my gratitude to my daughter Cheryl for sharing my passion; she has kept her eyes out for any paintings of stitchers and has discovered several that I had not. She has accompanied me to many foreign locations, providing me with companionship and greatly enriching the experience.

My sister-in-law Jessie Sirna, former art history professor and current dean of fine arts at Mott Community College in Flint, Michigan, started me off by searching her own slide collection for images of stitchers. She has always been my academic resource to fill in the huge gaps in my own knowledge of art history. In addition, she too has acquired slides or postcards for me from museums she has visited, often in remote corners of the world. My research has been greatly enhanced by her contributions.

My son Tony and his life partner Rachel have given me great assistance in the print production of my original research, which was done for the National Academy of Needlearts Honors Program. Their technical knowledge of computers and image reproduction has been of great assistance. My friend Sandy Meono has been my computer guru for several years now. Without her I would be floundering around with very rudimentary computer skills indeed. It is she who patiently answers technical questions and encourages me to acquire new skills. Furthermore, she even discovered a "stitcher" in Las Vegas!

My daughter Michèle makes sure I know what exhibitions are coming to the Houston Museum of Fine Arts, plans a visit for me, and definitely makes the visit worthwhile with her company, her cuisine, and my darling grandchildren, Connor and Isabelle.

Judy Lehman, a colleague in the National Academy of Needlearts, gave me the incentive—an extra push—to do more than just collect the slides, and to turn this into a research project.

Special people kept their eyes out for images of embroiderers and on many occasions invited me or accompanied me to art exhibitions. These include my sister Mimi Doherty and my good friends Zena Weimer, Chary Raymond, Christine Beck, and Judy Kraska.

A special debt of gratitude is owed to Shay Pendray for graciously agreeing to write the foreword for this book; her support has been most gratifying.

And finally, a special debt of gratitude is owed to Joan Louise Brookbank at Merrell Publishers for her immediate interest in my project, and for her continued support and encouragement, and to Anthea Snow, Nicola Bailey, Helen Miles, and Elizabeth Choi, all of whom work for Merrell, for their help in making my vision a reality.